FROM THE LIBRARY OF

GARY METZ

A 1972 GRADUATE OF VISUAL STUDIES WORKSHOP, GARY METZ WAS
AN ACCOMPLISHED PHOTOGRAPHER AND NOTABLE SCHOLAR.

OCTOBER 14, 1941 – SEPTEMBER 28, 2010

EXCITE YOUR SENSES

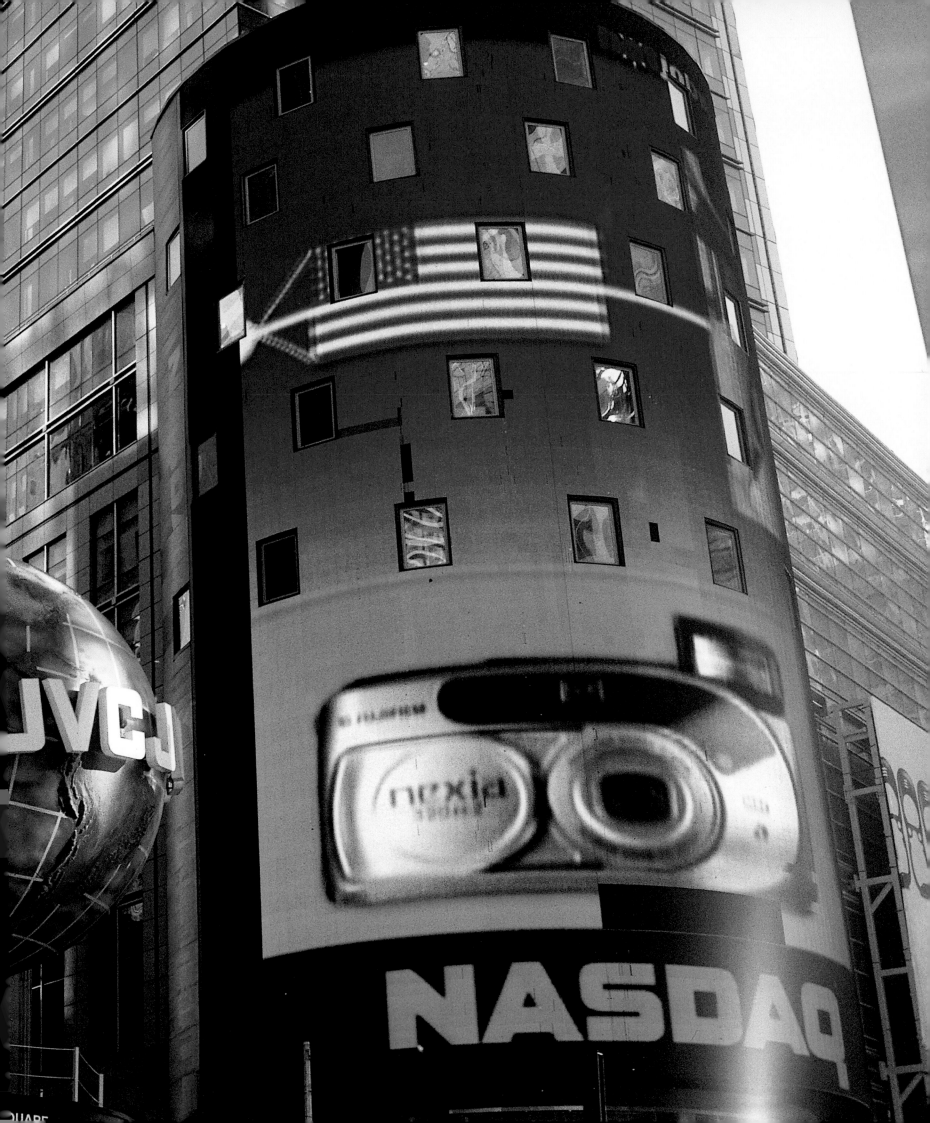

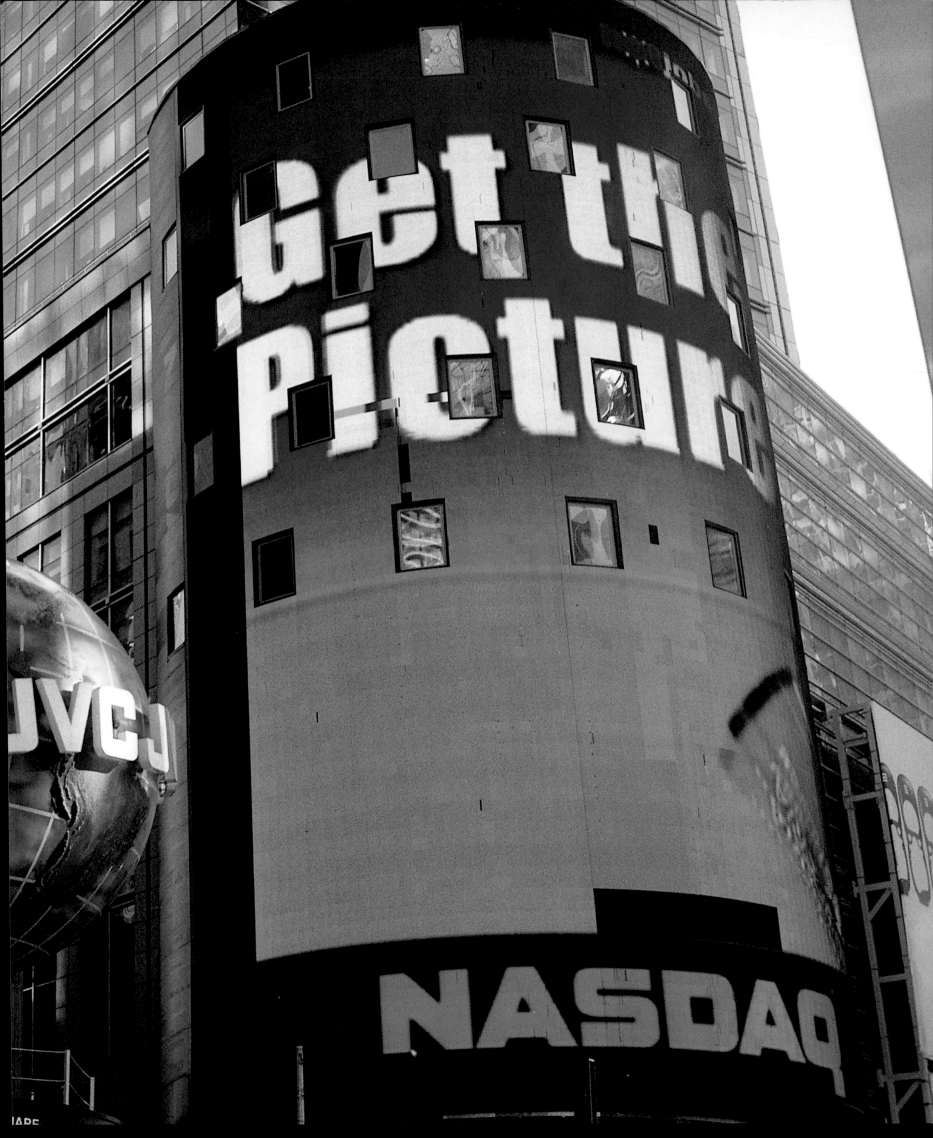

COLOR I

Robert Walker

S POWER

Thames & Hudson

For Ania and to the memory of my parents

Acknowledgements

I would like to express my gratitude to William Ewing, Director of the Musée de l'Élysée, Lausanne, Switzerland, for employing his impeccable eye in the choice and juxtaposition of images, and to Edwin Jacobs, Director of the Museum Jan Cunen in Oss, Holland, for his insights in the selection process and his help with the overall concept of the project. I am grateful to both museums for organizing a travelling exhibition of the work featured in this book. I would also like to thank Paul Heyer for his wise counsel and advice in the preparation of the text, and Clive Wilson of Thames & Hudson for his editing assistance which went well beyond the call of duty. I am particularly grateful to Max Kozloff and Jan Andriesse who contributed insightful texts to the catalogue edition of this publication. Finally, I am indebted to Philip-Lorca diCorcia for his generosity in allowing me to use the photograph of the author.

The publishers would especially like to thank William Ewing, Director of the Musée de l'Élysée, Lausanne, for conceiving and visualizing this project.

This book is published in conjunction with the exhibition *Colour is Power* at the Museum Jan Cunen, Oss, November 3, 2002 to January 27, 2003, and at the Musée de l'Elysée, Lausanne, October 30, 2003, to January 11, 2004.

First published in hardcover in the United States of America in 2002 by Thames & Hudson Inc., 500 Fifth Avenue, New York, New York 10110.

thamesandhudsonusa.com

Distributed in Canada by Penguin Books Canada Ltd.

Library of Congress Catalog Card Number 2002100533
ISBN 0-500-54259-7

Printed and bound in Germany by Steidl

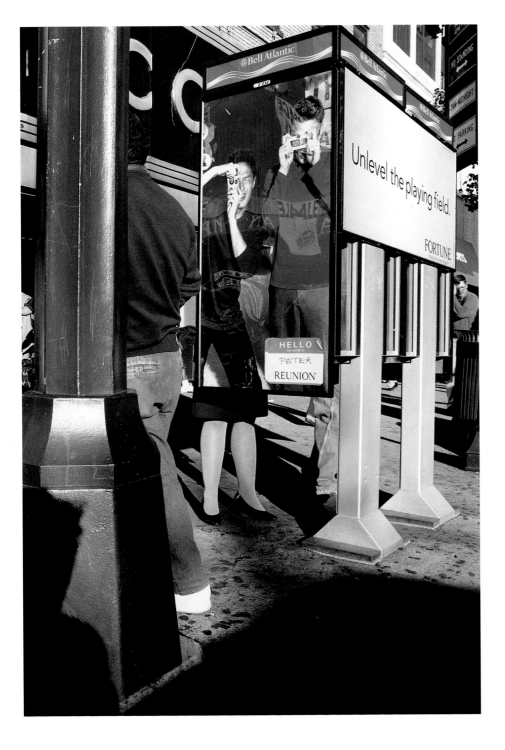

CONTENTS

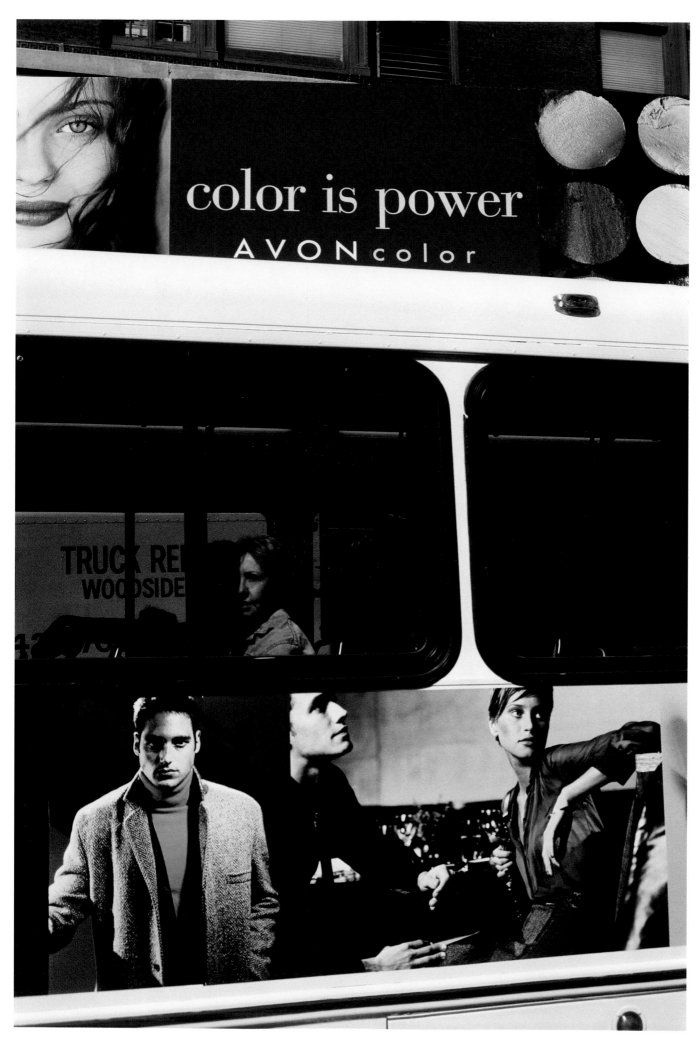

Colour is Power

'The true mystery of the world is the visible, not the invisible.'
Oscar Wilde

'Color is power' was an advertising slogan used by Avon in a recent campaign. Power for what? Power to seduce? Power to control? Mao stated that power emanated from the barrel of a gun. Marshall McLuhan countered that if America wanted to win the Cold War, it should scrap its missiles and bombard Moscow with Sears Roebuck catalogues. In our post-modern society, advertising has become increasingly oblique and elliptical. More than ever, colour has become a prime ingredient to gain attention in the mediascape of the new millennium, or as Canon shamelessly bellows: IMAGE IS EVERYTHING!

Snowblind
Many years ago while at a friend's house, I was watching a film on television called *Scott of the Antarctic*. Outside, a fierce snowstorm raged. The TV set was positioned close to a window, which created an uncanny relationship between the snowy TV screen and the actual snow pelting the windowpane. In the movie, Scott and his crew trudged blindly through a blizzard to their demise. After the film, I left the apartment and headed home. To my surprise, all public transportation was halted because of the storm. I had to walk home five miles through an onslaught of sleet and snow. When finally I arrived, my feet were nearly frozen. Today, the blurring between the urban landscape and the mediascape increasingly typifies our world.

Clothes make the man (invisible)
In my youth, my role model was the film director John Cassavetes. Back then, he starred in a weekly TV series called *Staccato*. Johnny Staccato was a hipster private eye whose office was an all-night jazz club where he would often sit in with the band on piano. What impressed me most about Staccato was his wardrobe. He wore a dark plaid sports jacket and tie, which gave him the chameleon-like ability to manoeuvre through all strata of society without suspicion – a model which has served me well as a street photographer.

Camera shy
I am often asked if I encounter hostile situations when photographing strangers on the street. My answer is that I have had a few tense moments but to avoid confrontation I have learned a couple of tricks over the years. After snapping a picture, most people remove the camera from their eye and look directly at the subject. I find that if I look elsewhere, the person experiences a moment of disbelief and assumes that their eyes are playing tricks. In case this does not work, I always make sure I wear a pair of good running shoes for a fast getaway.

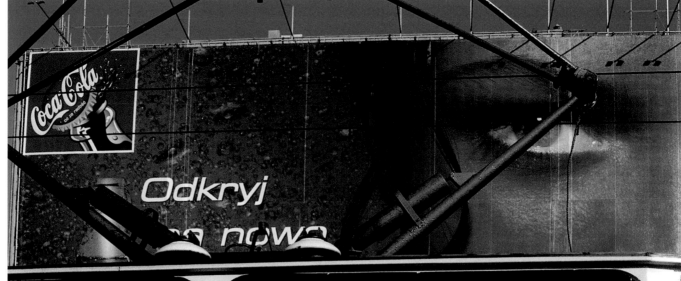
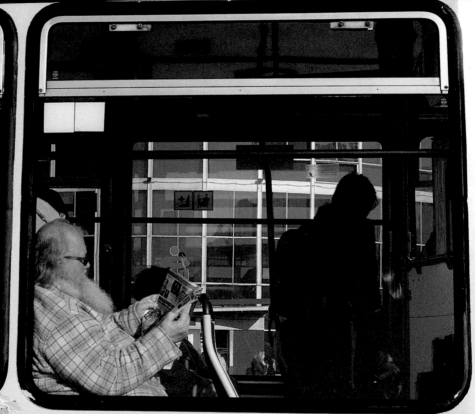

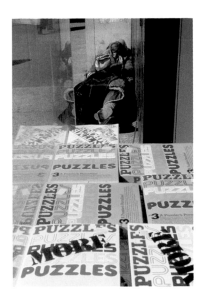

The last picture show

In 1839, with the invention of photography, painting was declared dead. Although an exaggerated statement obviously uttered for effect, it contains a grain of truth. New styles and technologies radically alter or throw into obsolescence previous modes of expression and production. Now, with the digital revolution, which makes it so easy to produce, manipulate and disseminate images, a fundamental change is occurring.

Pixel perfect?

Currently, a rumour abounds in the photographic community about the imminent death of Kodachrome film, yet another casualty of the digital age. Introduced in 1936, Kodachrome has always been the preferred choice of professionals because of its capacity to produce richly saturated hues and for the longevity of the colour dyes. I have always suffered from the delusion that the film has a supernatural ability to absorb the most vibrant colours from the environment and render them in an almost tactile way. With the digital revolution, I do not suffer the same delusions. What a let-down it is to view on-screen images taken with a digital camera, the colour 'democratized' by insipid pixels. Younger photographers tell me that I had better get used to this state of affairs. As emulsions give way to pixels, I wonder if digitization is synonymous with desensitization?

State of the art

Although experiments in colour photography go back to the mid-nineteenth century and a practical method of colour photography dates from around 1900, technical difficulties did not allow it to become feasible for artistic purposes until the 1960s, when faster films and simpler printing techniques became available. Even then, the medium was shunned by 'art' photographers as being crass and vulgar, in large part because commercial photographers had appropriated it. In the introduction to his seminal book *The Decisive Moment*, Henri Cartier-Bresson expressed his ambivalence concerning the use of colour:

> The difficulties involved in snapshooting are precisely that we cannot control the movement of the subject; and in colour-photography reporting, the real difficulty is that we are unable to control the inter-relation of colours within the subject.

During the 1970s, the first generation of photographers appeared who used colour as an intrinsic ingredient of their work. The last quarter of the twentieth century will probably be recognized as the golden age of colour photography, but its grammar and syntax became over-used and stale and the genre slid into mannerism. Today, digitized imagery, which begs to be manipulated and adulterated, has moved centre stage. The credibility of all imagery is now suspect. The era of the photograph that bears witness is gone forever.

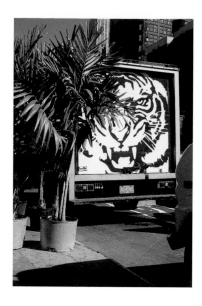

Broadway boogie-woogie

When I went to art school in Canada in the 1960s, American cultural imperialism was rampant. The New York colour-field painters and Pop artists ruled the roost. I admired the cool formalist abstractions of Kenneth Noland, Morris Louis and Ellsworth Kelly, but the Pop artists offered more tangible lessons of how to deal with iconography and the juxtaposition of natural and industrial forms. Roy Lichtenstein's comic book graphics with their dry wit, James Rosenquist's monolithic paintings of chrome, grass and spaghetti, and the subliminal psychological montages of Robert Rauschenberg had a big impact.

Self-portrait

In 1975, the American photographer Lee Friedlander was invited by the Optica Gallery in Montreal to give a workshop on street photography. I registered for the course on a whim rather than out of any deep interest. During this period, I was also introduced to the work of the masters of the genre: Eugène Atget, André Kertész, Walker Evans, Robert Frank, William Klein and Gary Winogrand and as the workshop progressed, my fascination with this form of photography turned into an obsession.

A few months after the workshop ended, it occurred to me that I should immediately switch to colour. I intuitively felt that the creative possibilities of black and white were being exhausted. I have not taken a black and white picture since. At that time, there were few colour photographers to emulate, but at least I had my limited knowledge of painting to fall back on, so I approached the medium with an abstract sensibility. When I chose a subject to be photographed, I would completely ignore the literal elements and concentrate on balancing colour and form. If I learned anything from my early days as a painter, it was to be able to look at the entire picture plane as an abstraction and not be seduced by the drama of the subject matter.

Time on Times Square

From 1978 to 1988, I lived adjacent to Times Square and developed a love/hate relationship with it. Since then, the Square has undergone a fundamental transformation that has made it almost unrecognizable to baby boomers like myself. When I mention to GenXers that I remember commercial artists on scaffolds painting the billboards by hand, they look at me aghast as if I was nostalgically recalling the days of steam trains.

For a quarter of a century I have observed an endless stream of tourists from all parts of the world wandering through Times Square, trance-like, eyes directed upward, often with mouths agape. It's a scene that reminds me of descriptions of medieval people's experience of the Gothic cathedral. For them, the cathedral was a primary source of information. Biblical tales and moral

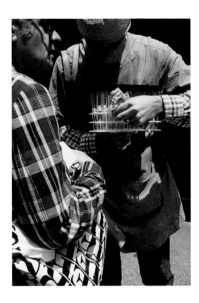

lessons glowed from stained-glass windows and painted images. On Times Square, the Virgin Mary is replaced by a surgical-masked huckster flogging plastic test-tube babies at two bucks a crack, while popular superheroes oust Christ's apostles; a colossal inflated Superman emerges *deus ex machina* to save the day; a fake Rocky signs counterfeit autographs and the 'real' Roy Rodgers appears in the flesh to open his 428th restaurant. Sacred texts that were once chiselled in cathedral walls have now given way to light-emitting diodes and monumental digitized photo billboards that encourage accumulation and self-gratification. However, one religious element still remains. Sidewalk evangelists bark catatonically into their loud-hailers, 'The end is near! Repent!' Times Square can be seen as a microcosm of the delusions and pathologies of the modern world, a contagion of increasingly global proportions.

Times Square has been a site of source material for painters and photographers for over seventy-five years. For some street photographers, it is what Mont Saint-Victoire was for Cézanne or Giverny for Monet. Electric signs, billboards and ink-jet murals offer up a multitude of iconographic illusions for the taking. Deep canyons of concrete and glass cast dark, mysterious shadows, causing peculiarities of scale and creating odd juxtapositions, while the absence of the horizon line enables photographs to be composed on an illusory, 'flat' surface.

Naked City/Naked Lunch

For my first book *New York Inside Out*, published in 1984, William Burroughs wrote the introductory essay. Wanting to put a more positive spin on the city of New York, my editor opted to delete the following passage:

> All the fragments are jumbling and shifting, throwing out pieces of paintings, the sky and billboards. Is this the face of the city? Yet how few of these faces have any urgency, any purpose, any grandeur. These are the anonymous meaningless faces of a city, a death trap. The whole city is a backdrop which could collapse at any moment or run together. Red and black, furnaces, oranges, the smell of burnt plastic and rotten citrus.... Split pictures spliced to each other without a soul and so is the City itself. Photos are just that. The people who inhabit it…spliced photos.

Apocalyptic images – words more in keeping with a biblical prophecy.

For me, photography is an act of defiance and confrontation against the blinding impact of increasingly accelerated imagery – a pause in which to wonder at and appreciate the world's peculiarities and complexities; to provide, as Robert Frost once described poetry, 'a momentary stay against confusion'.

Actual Size

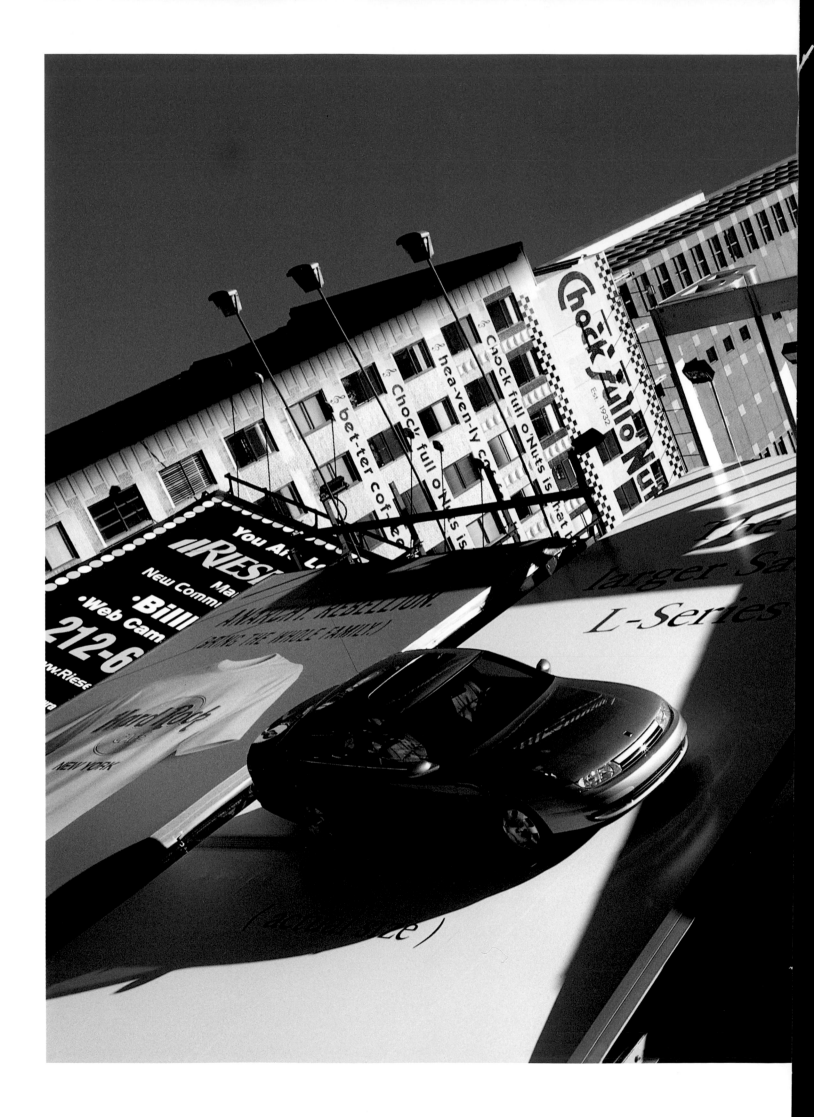

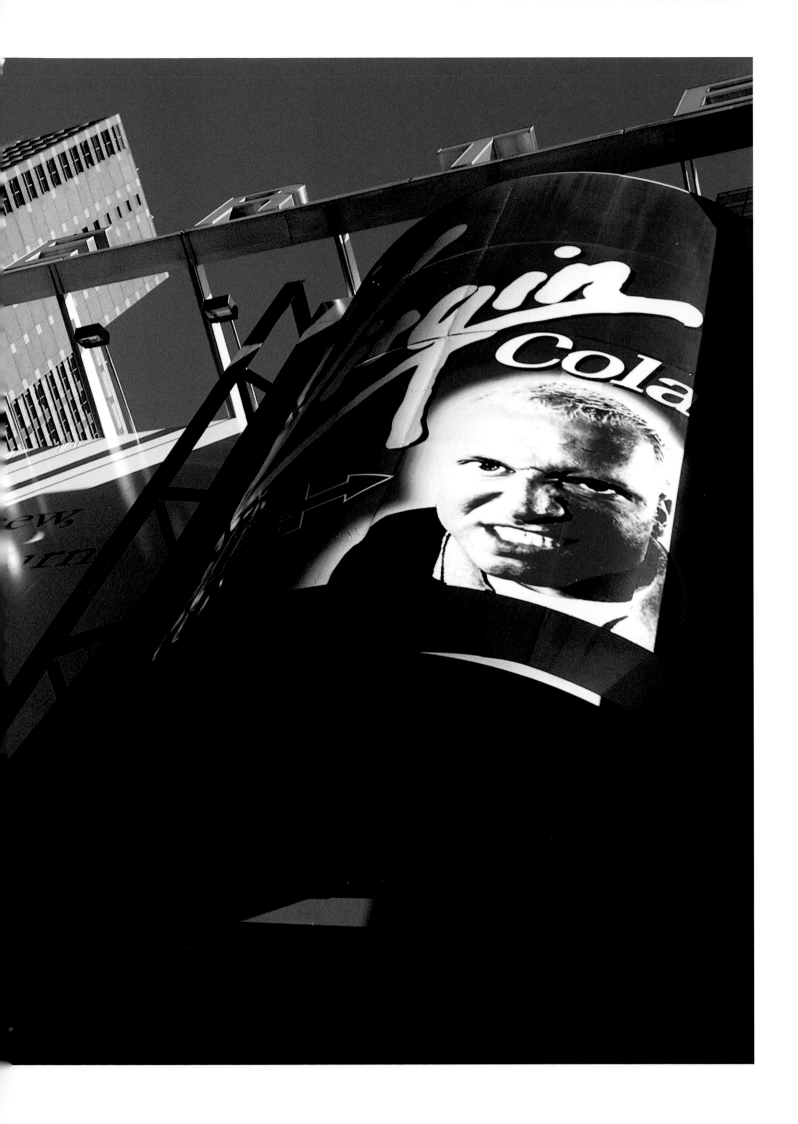

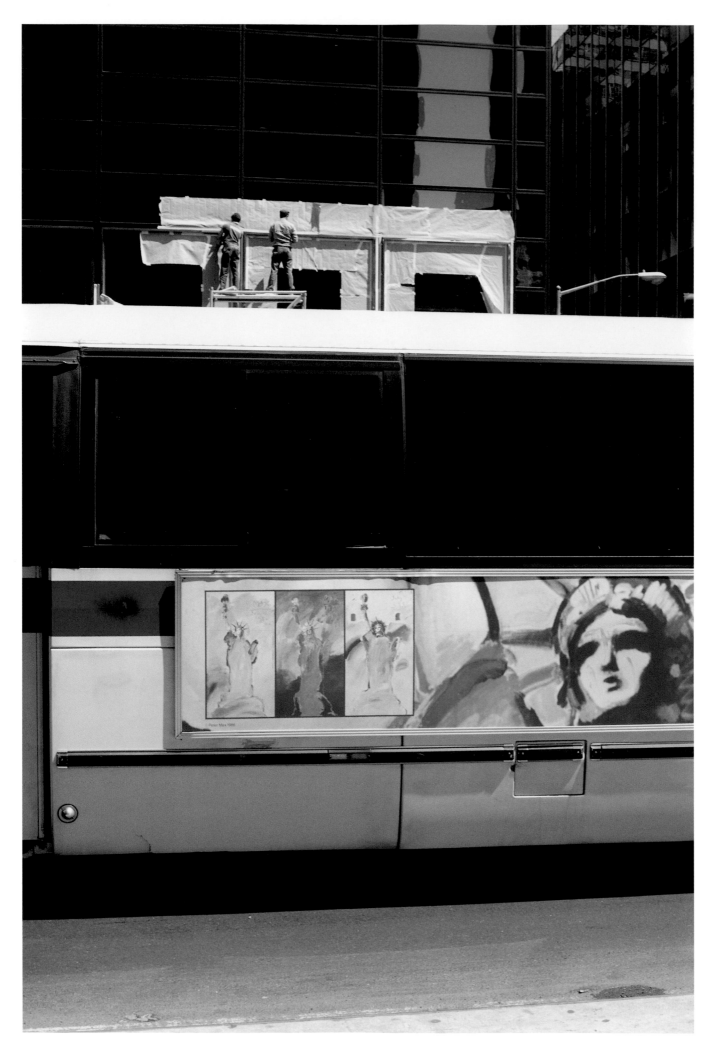

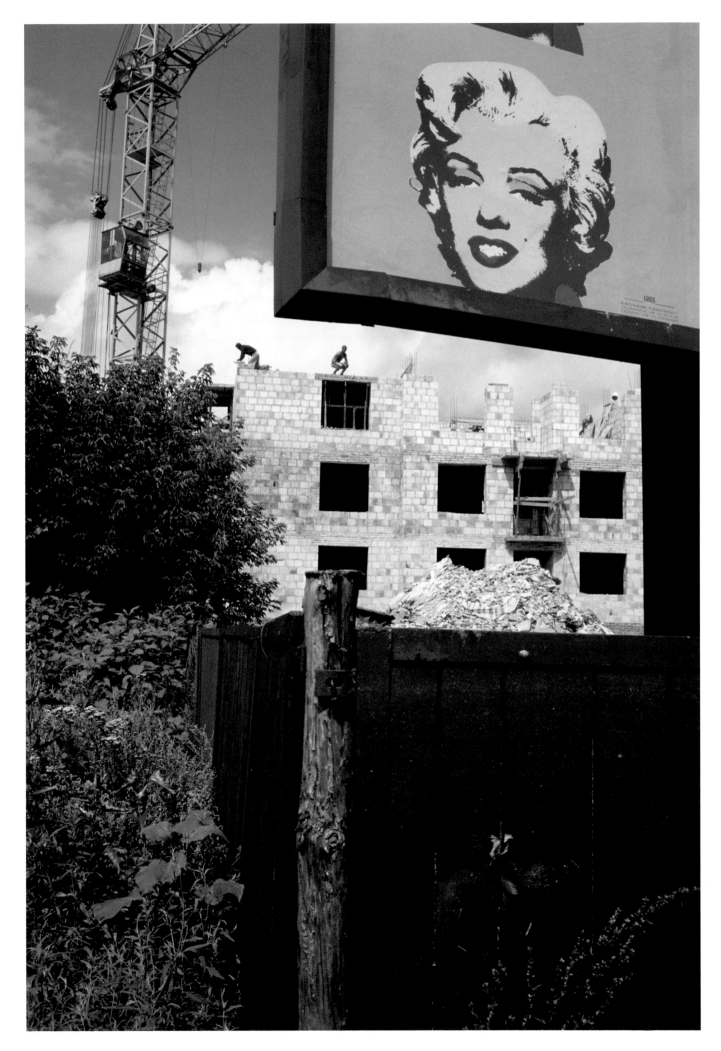

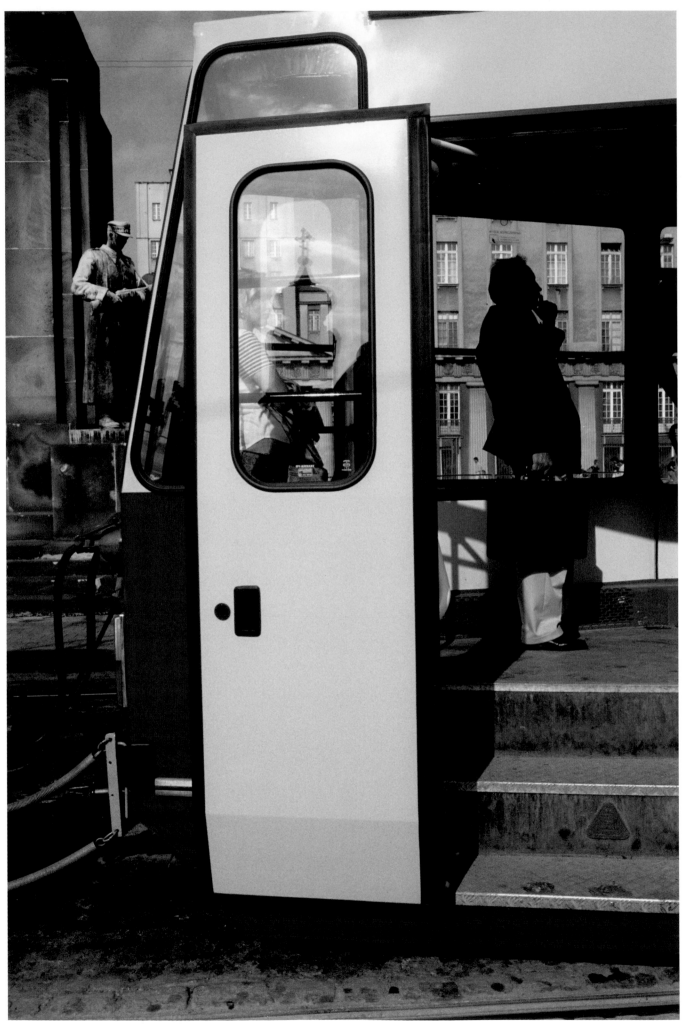

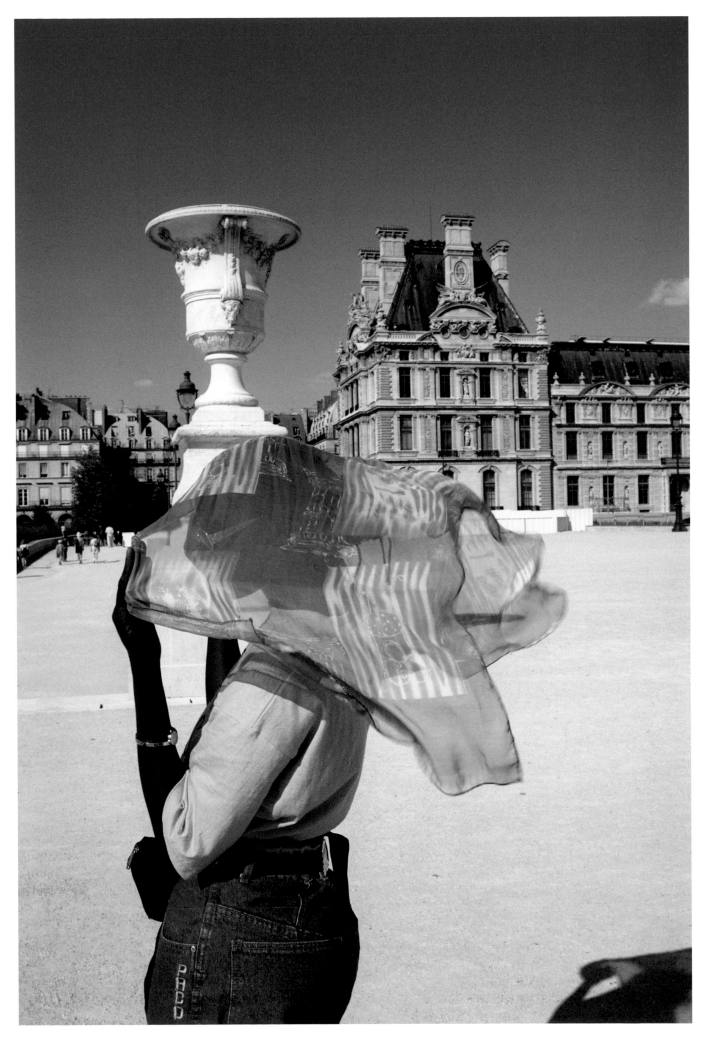

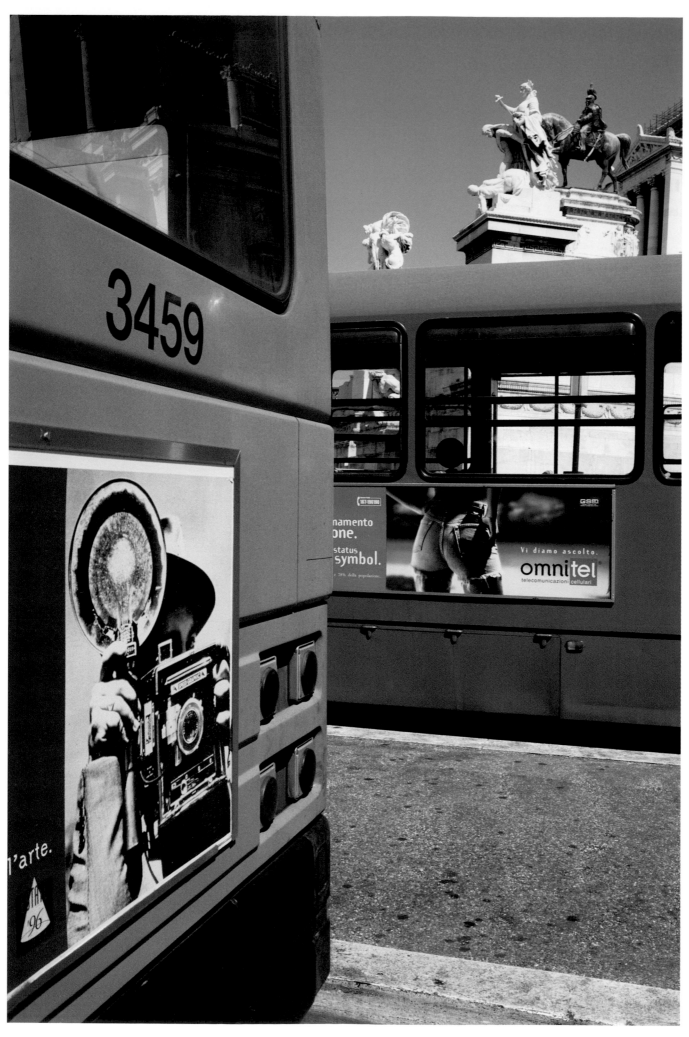

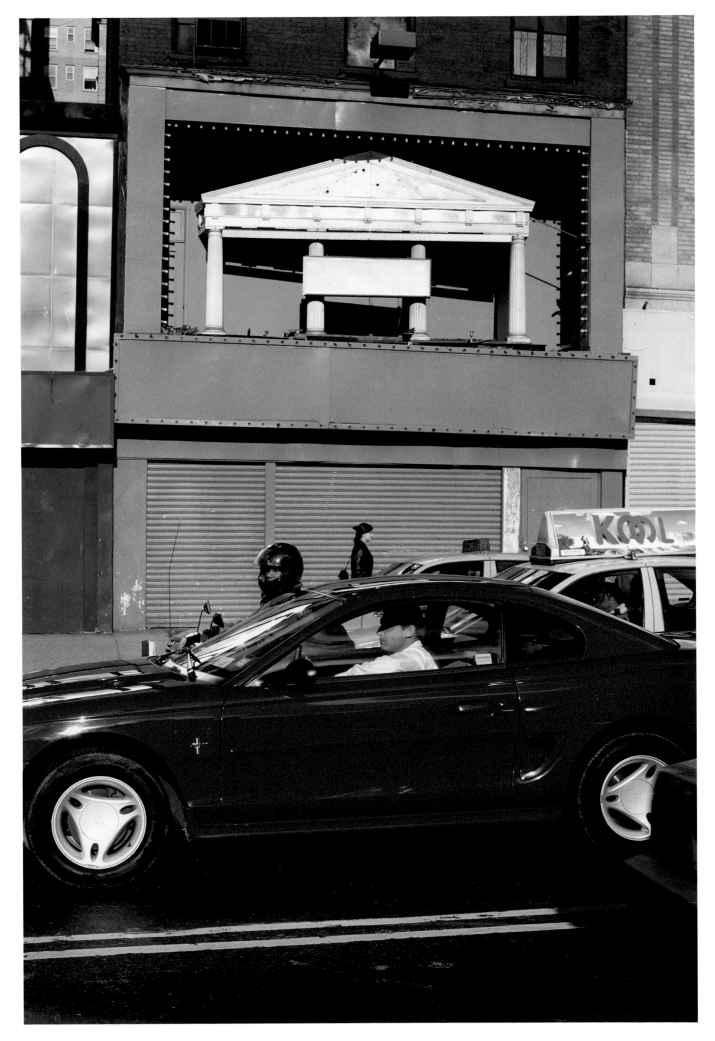

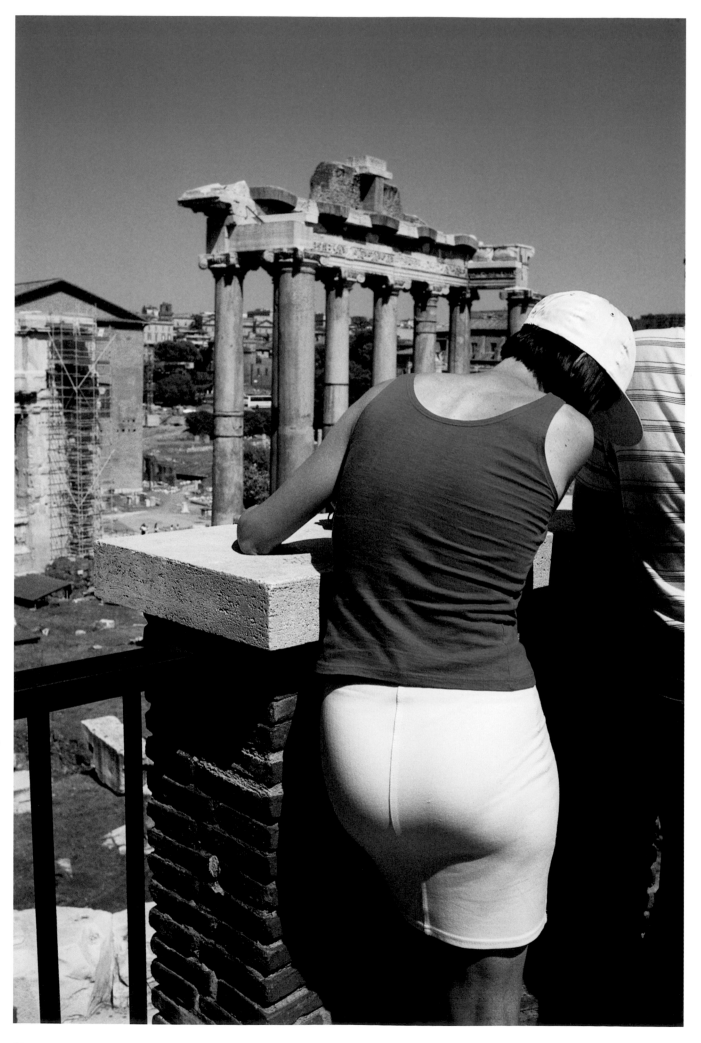

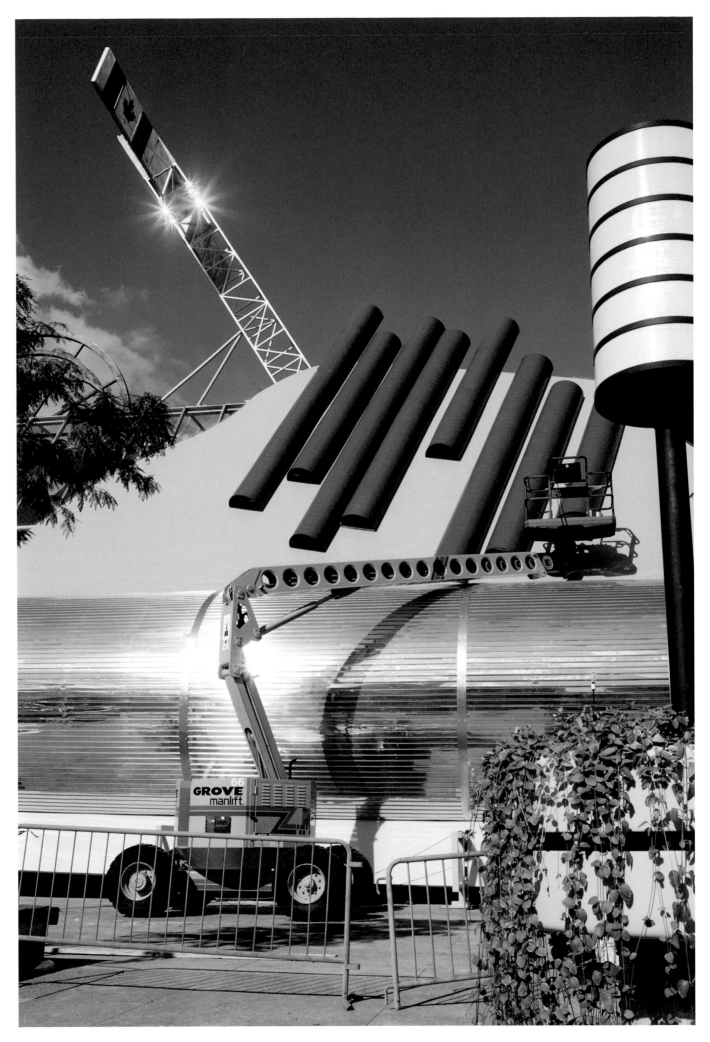

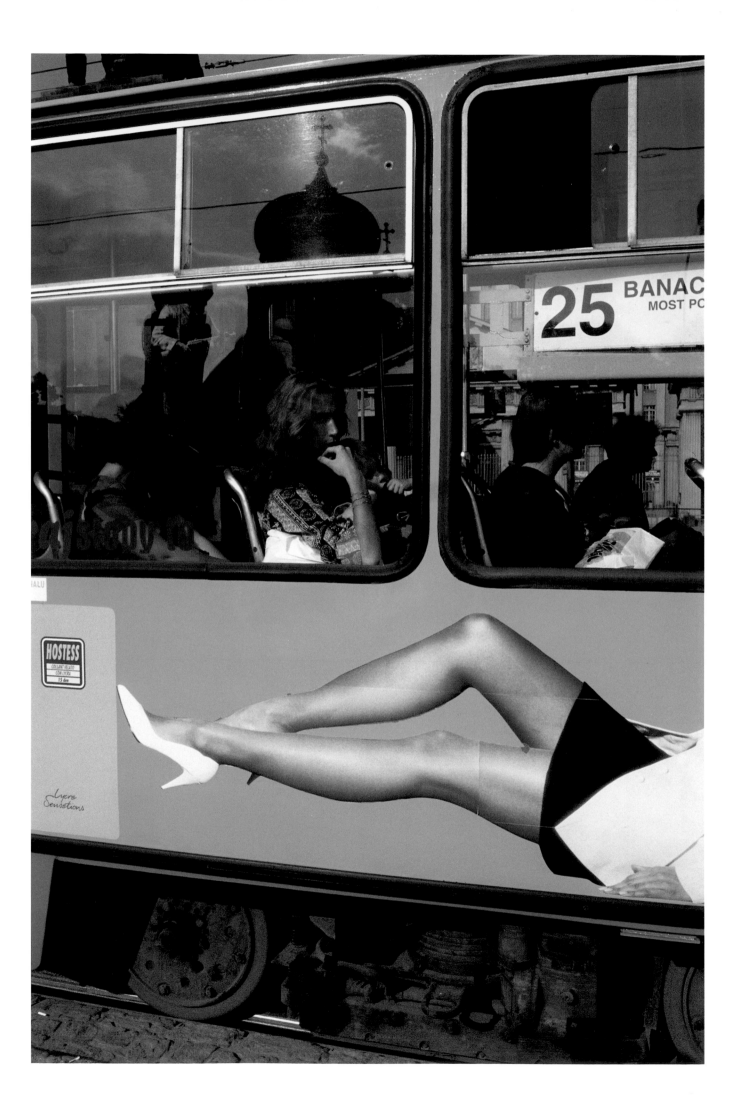

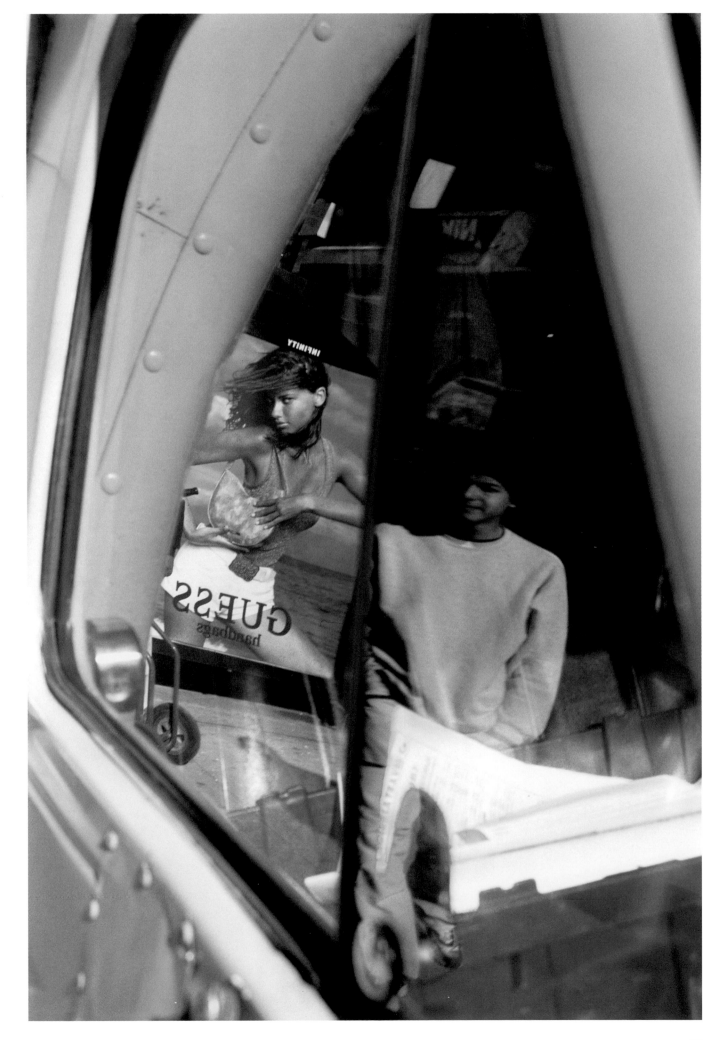

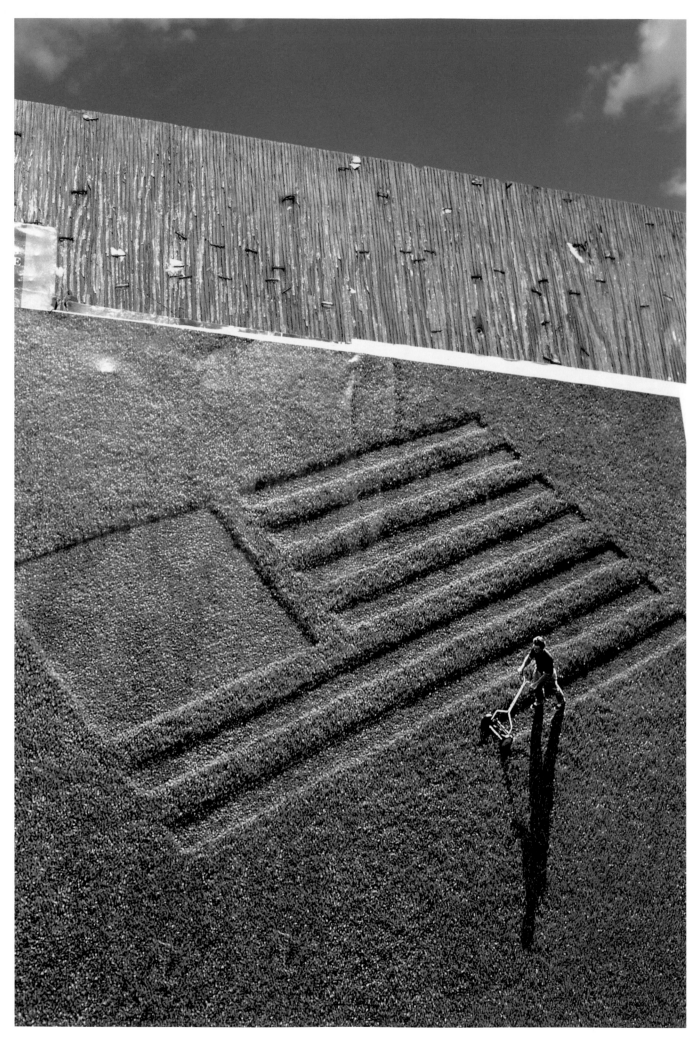

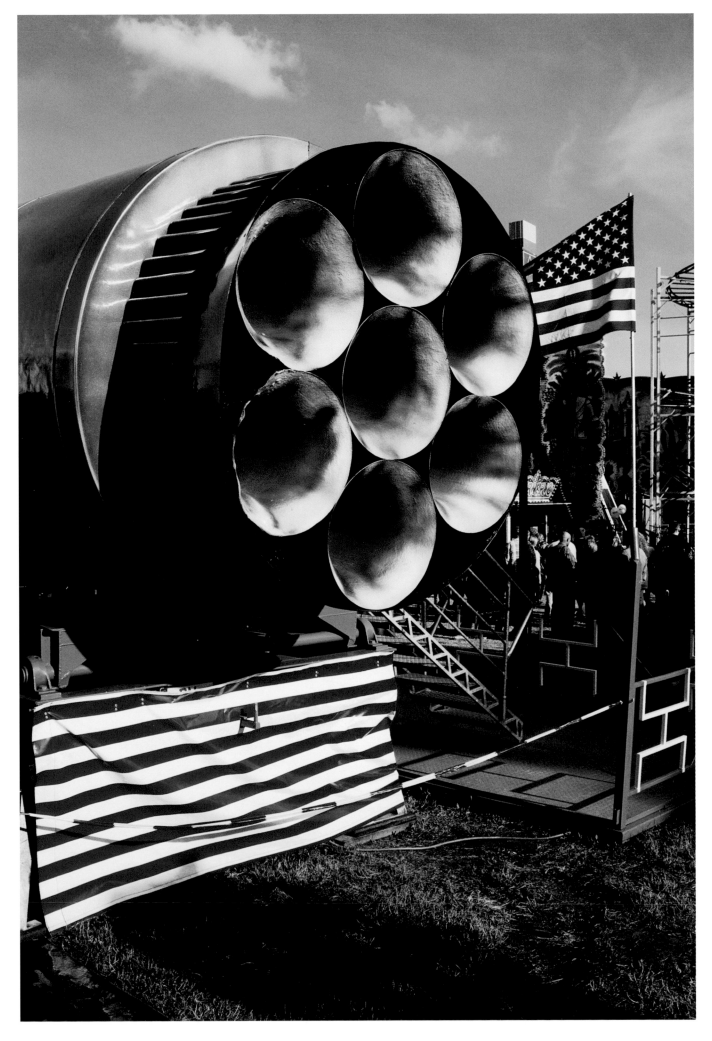

Think Different

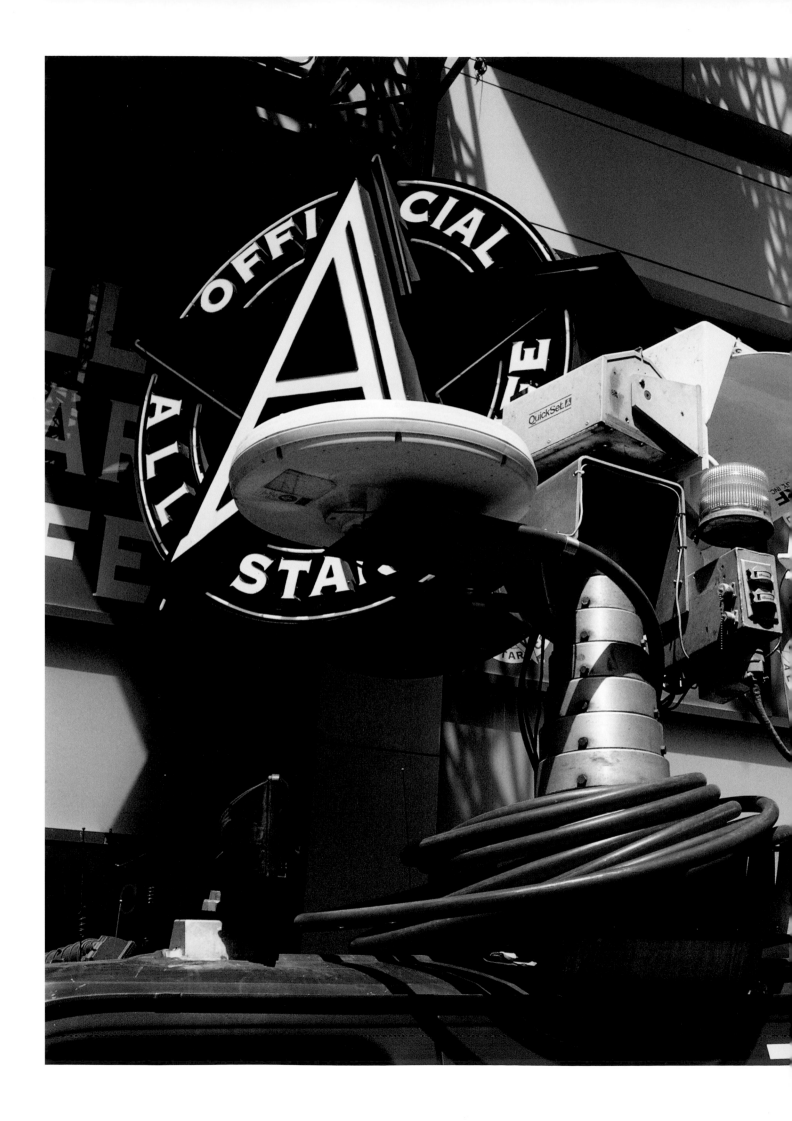

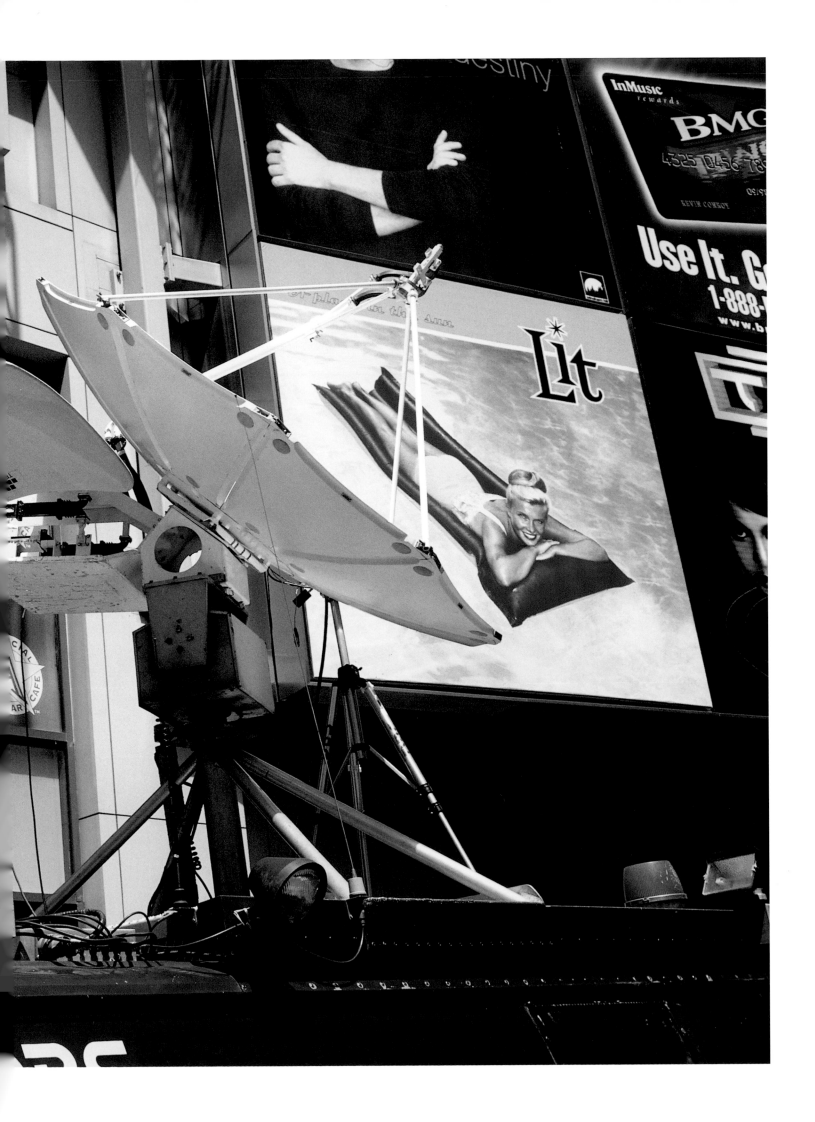

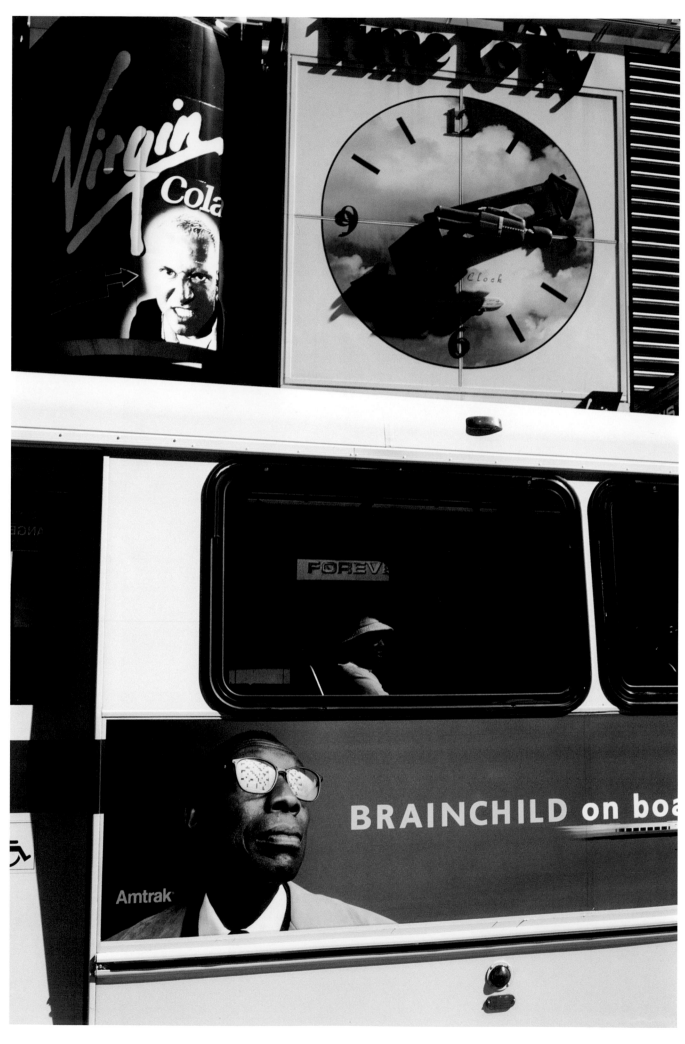

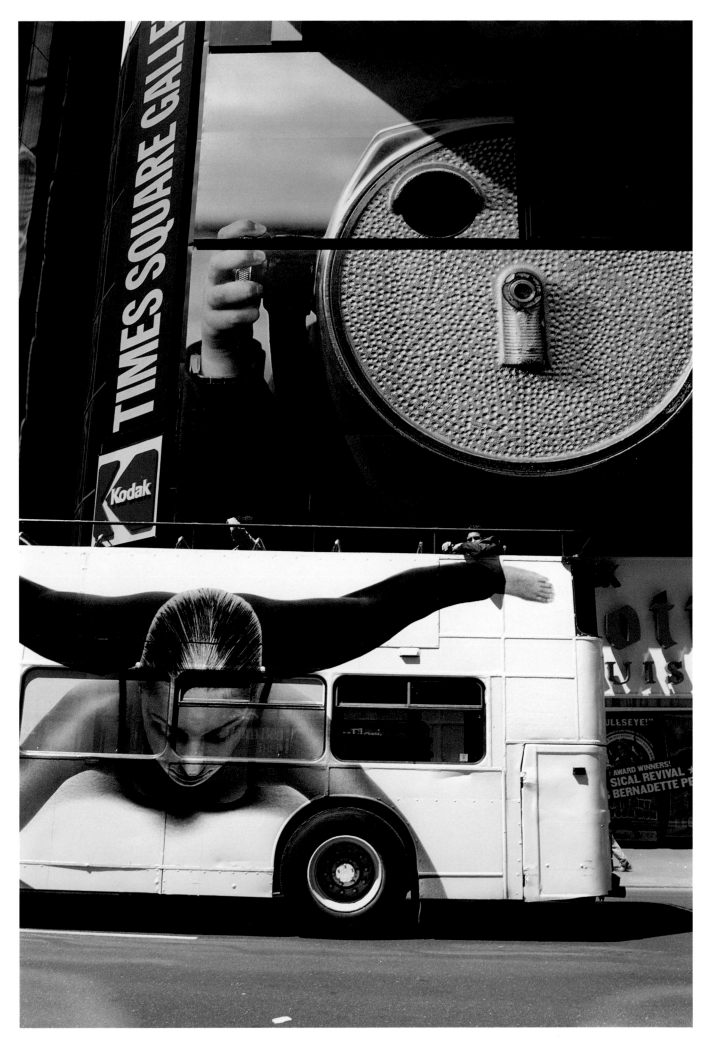

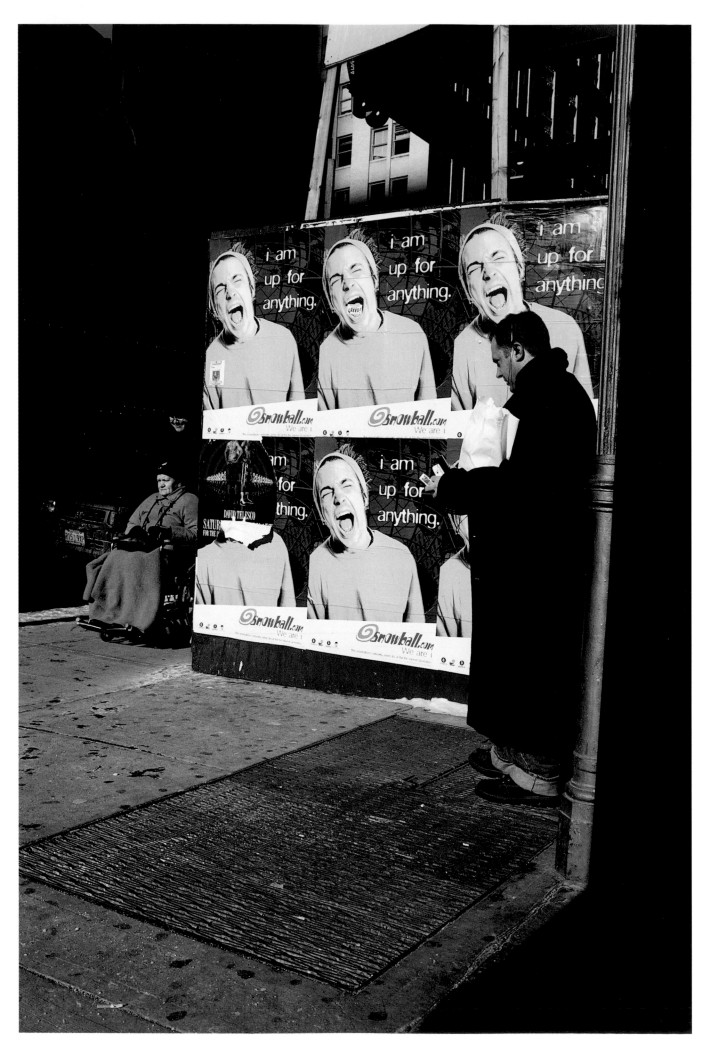

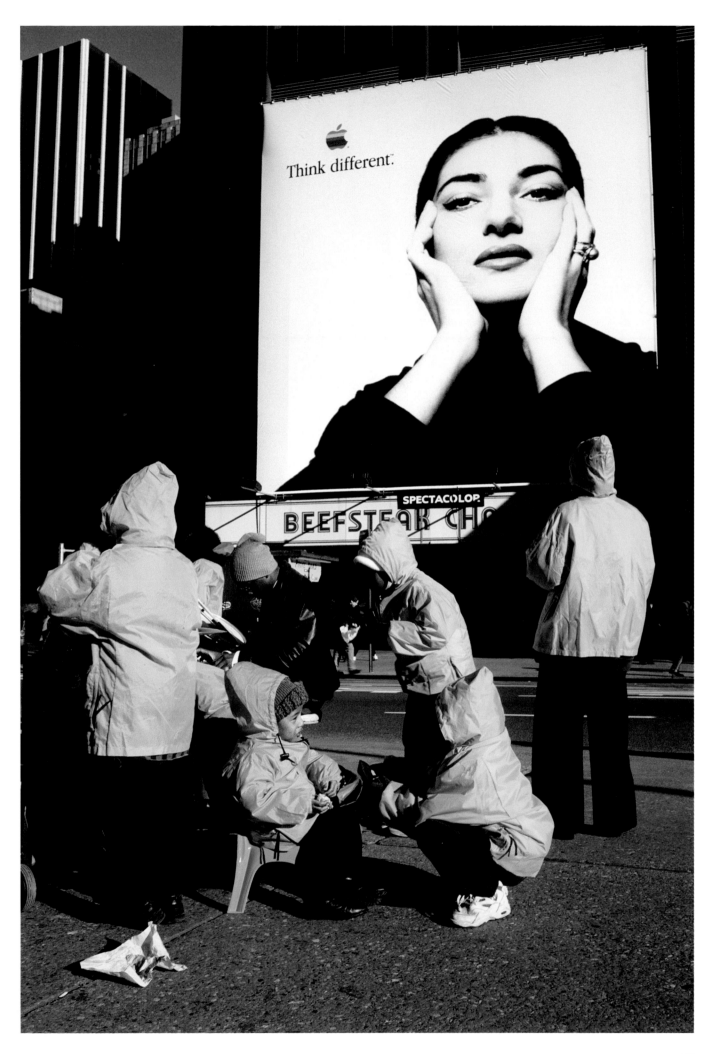

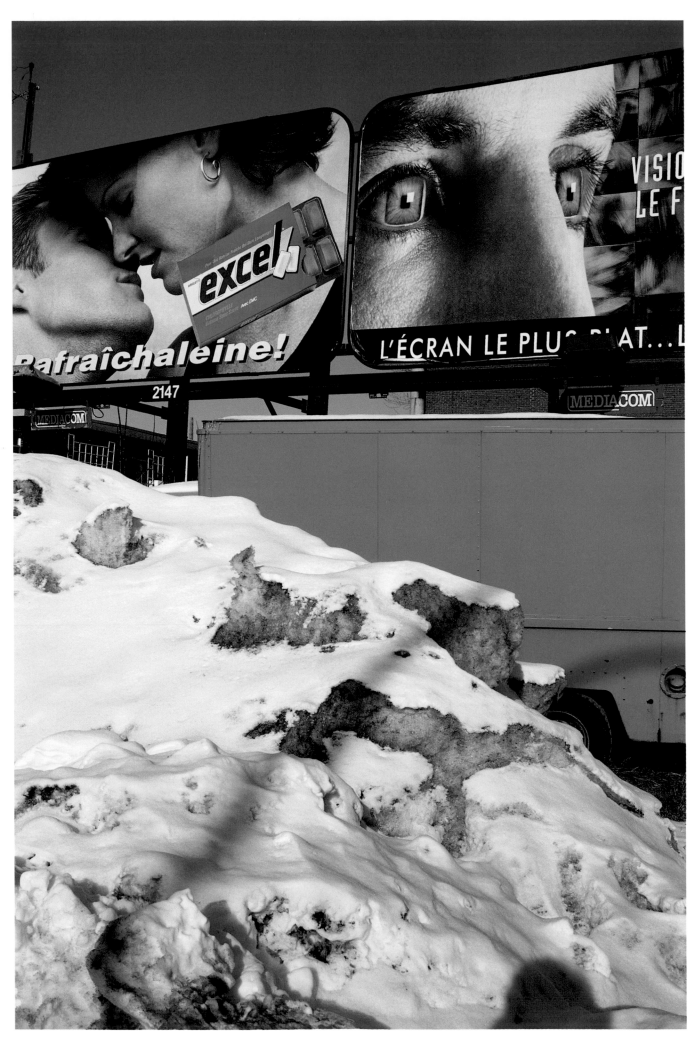

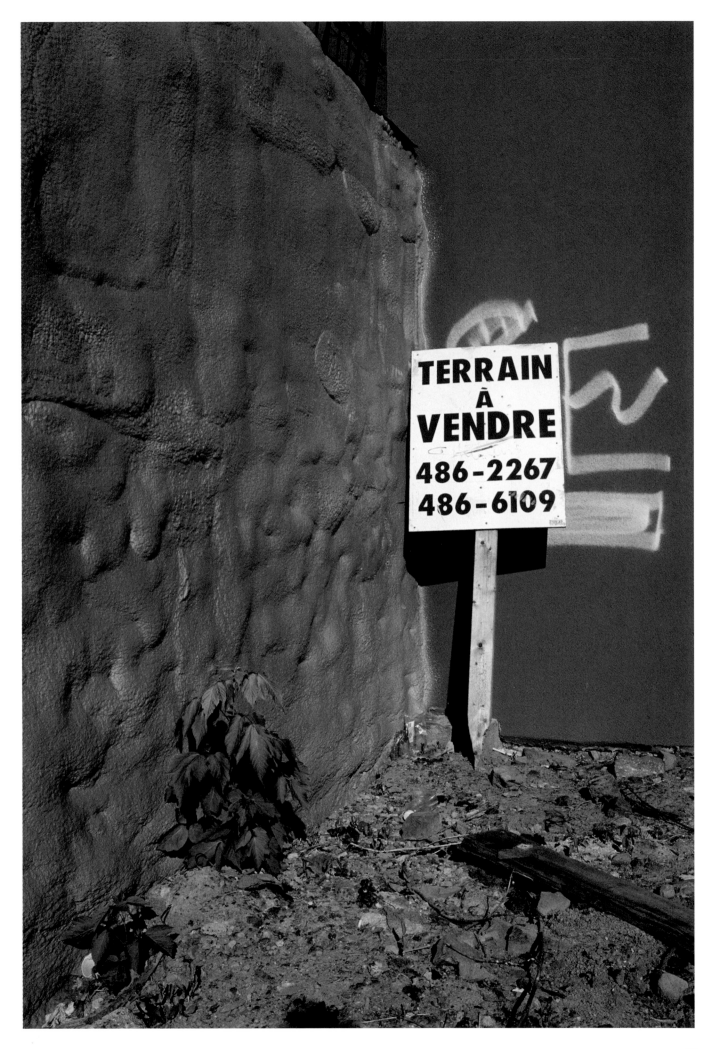

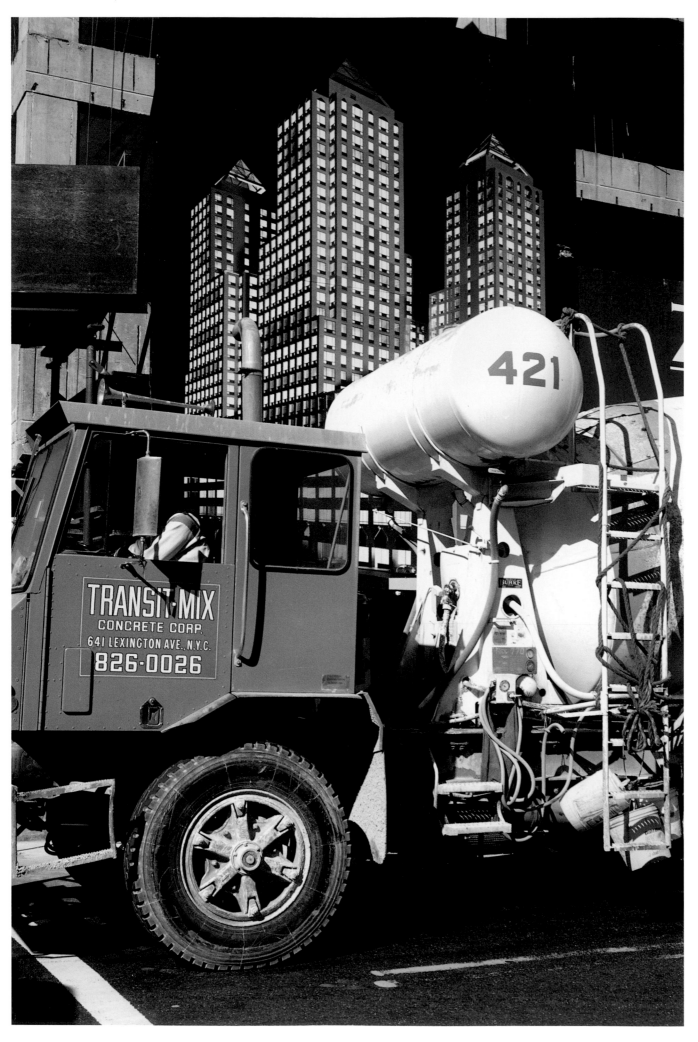

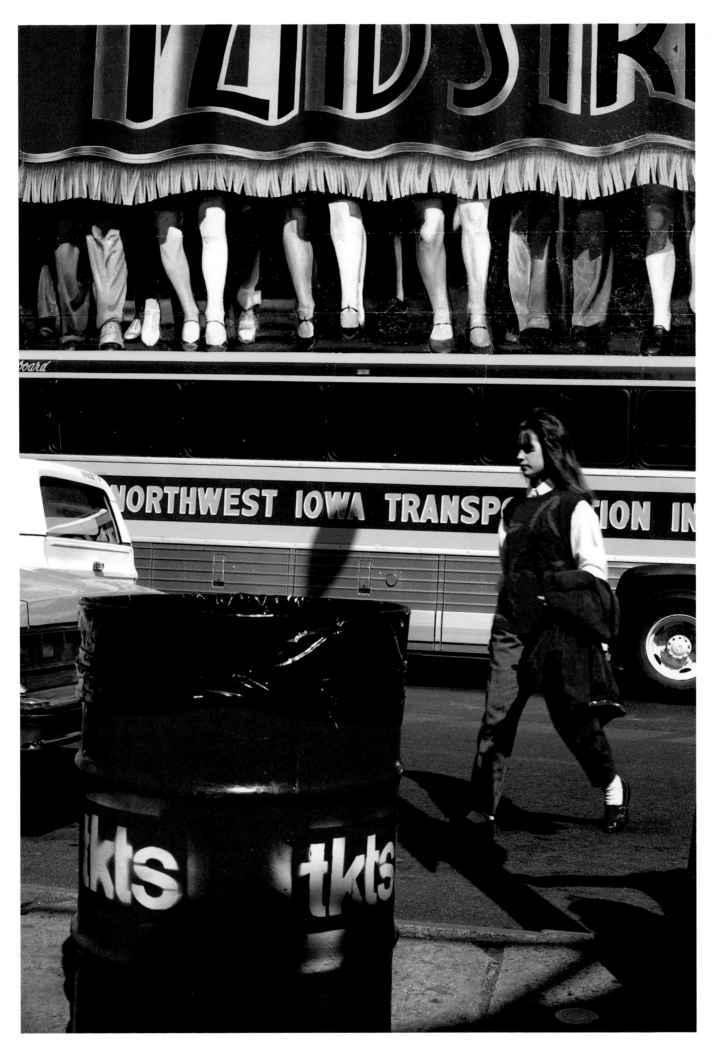

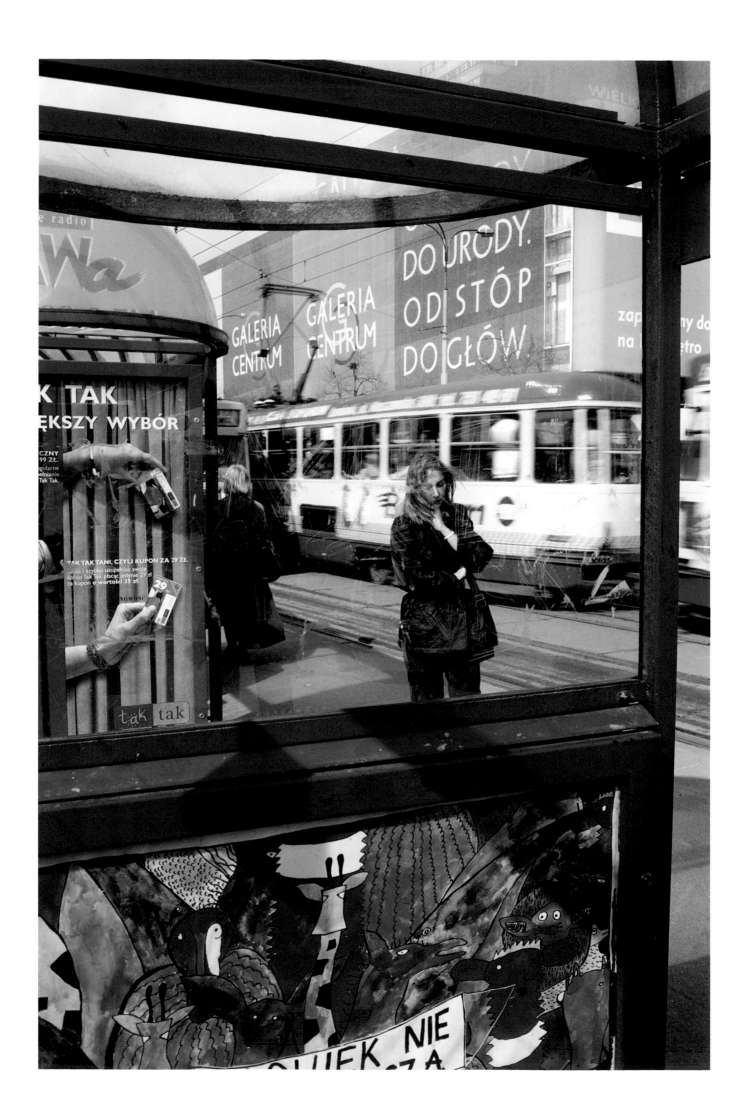

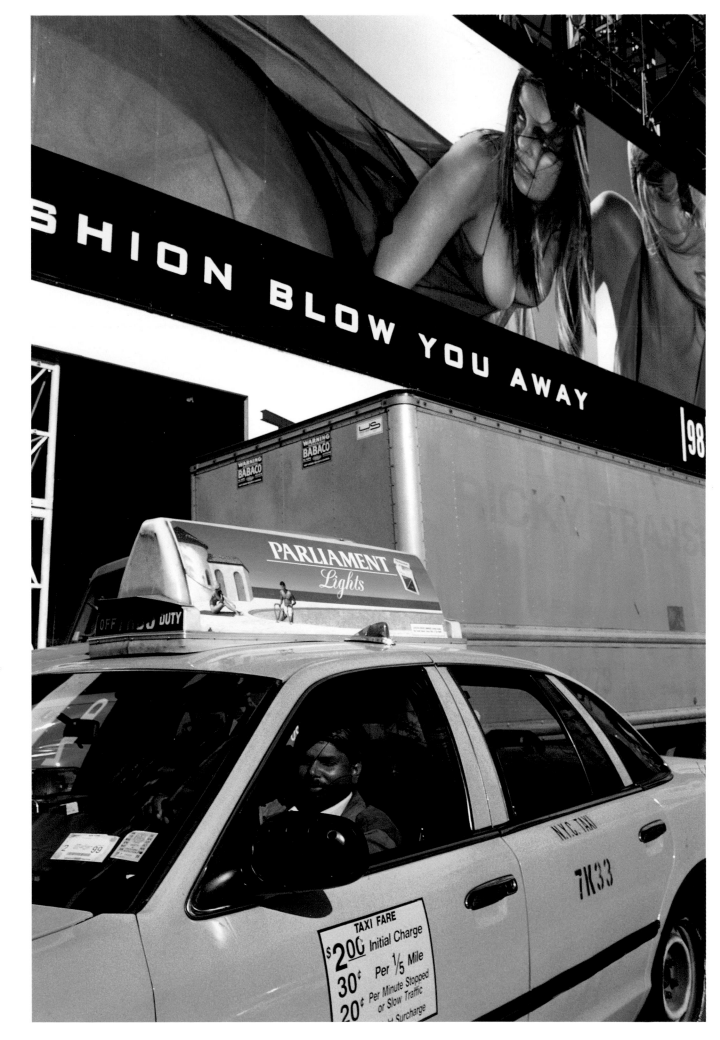

53

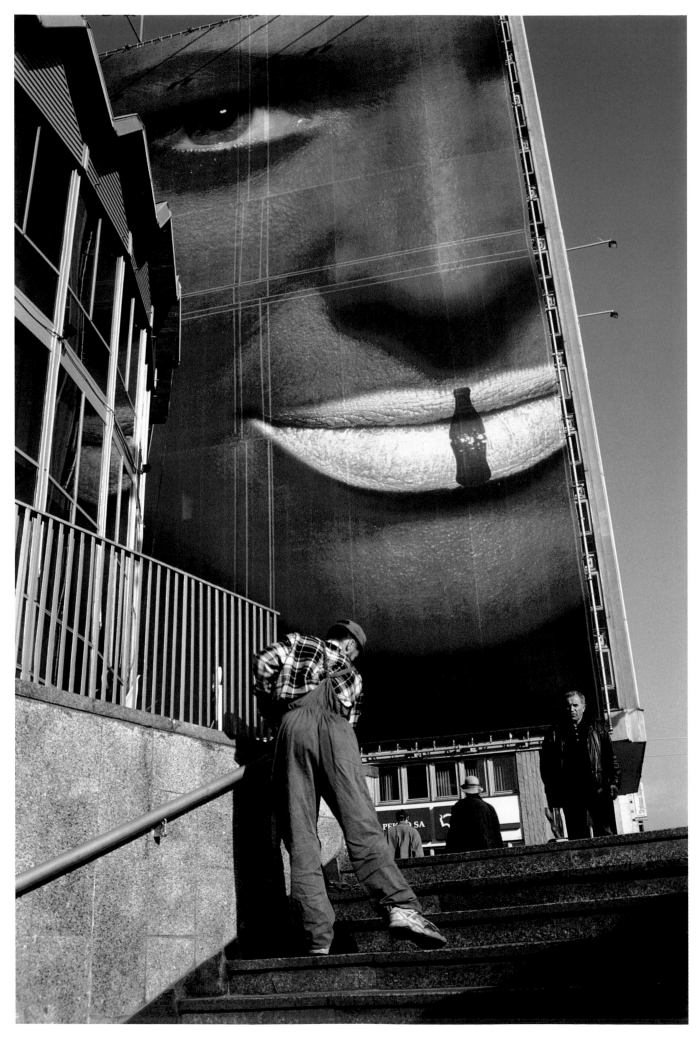

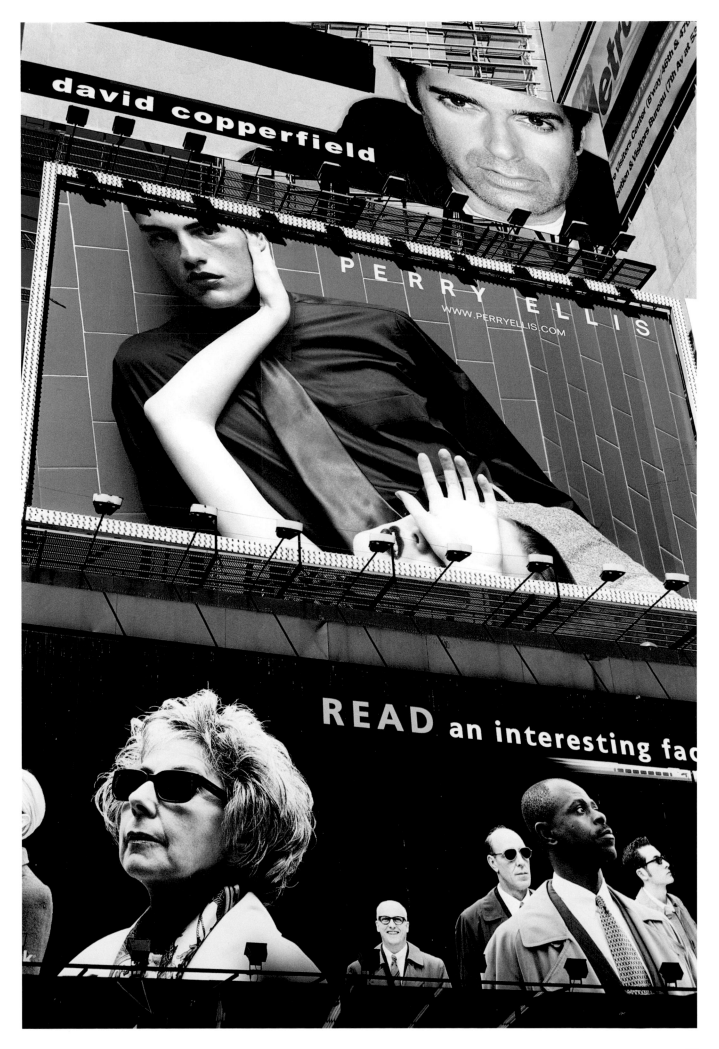

Redeem All

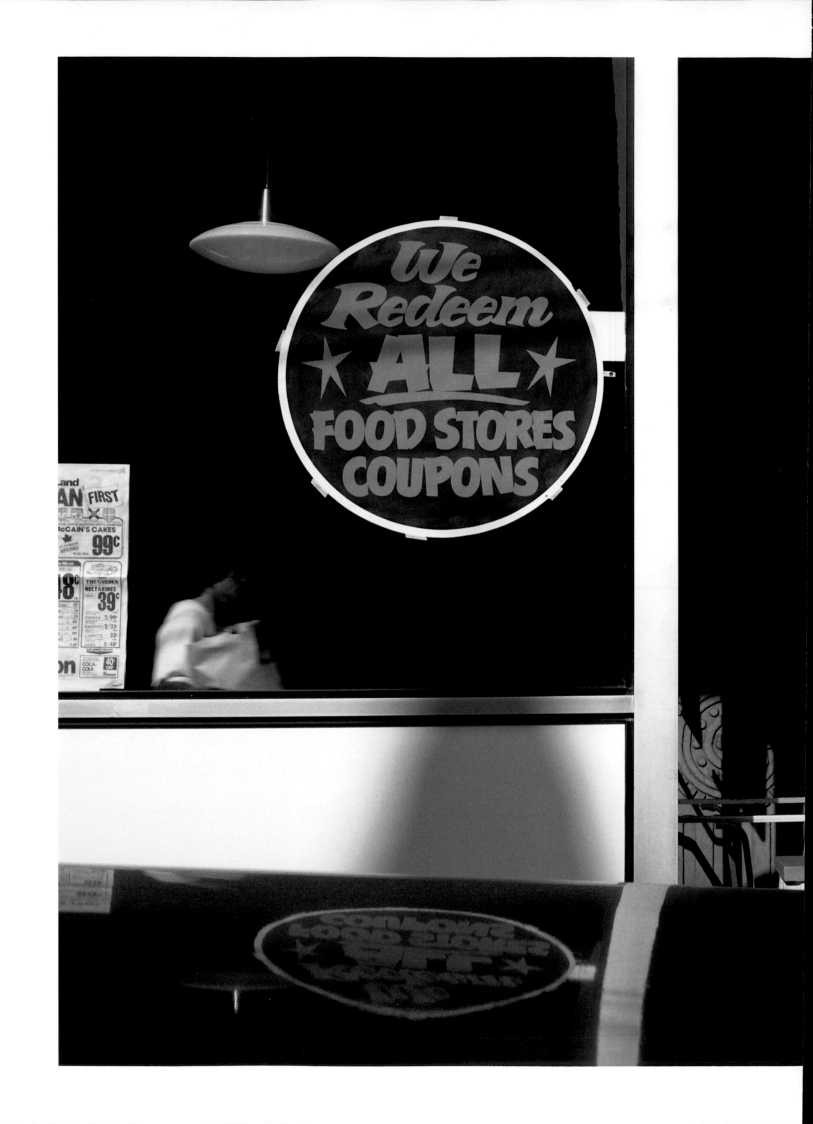

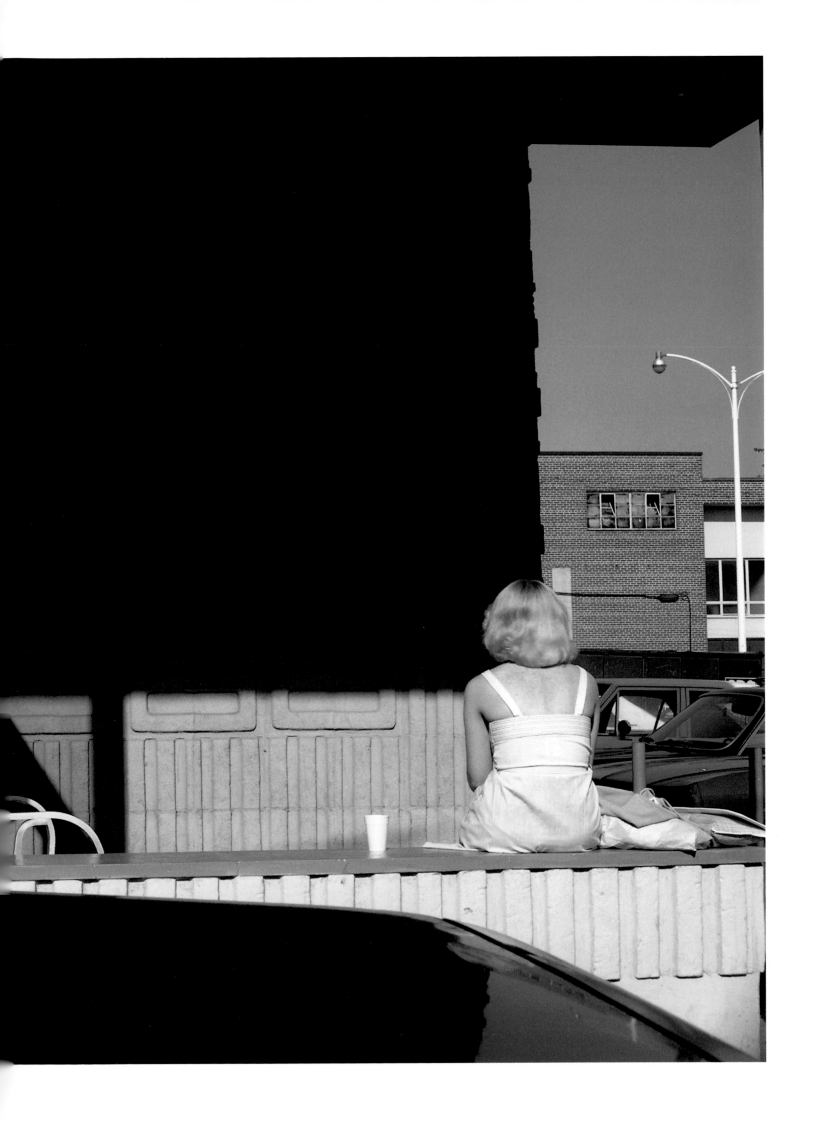

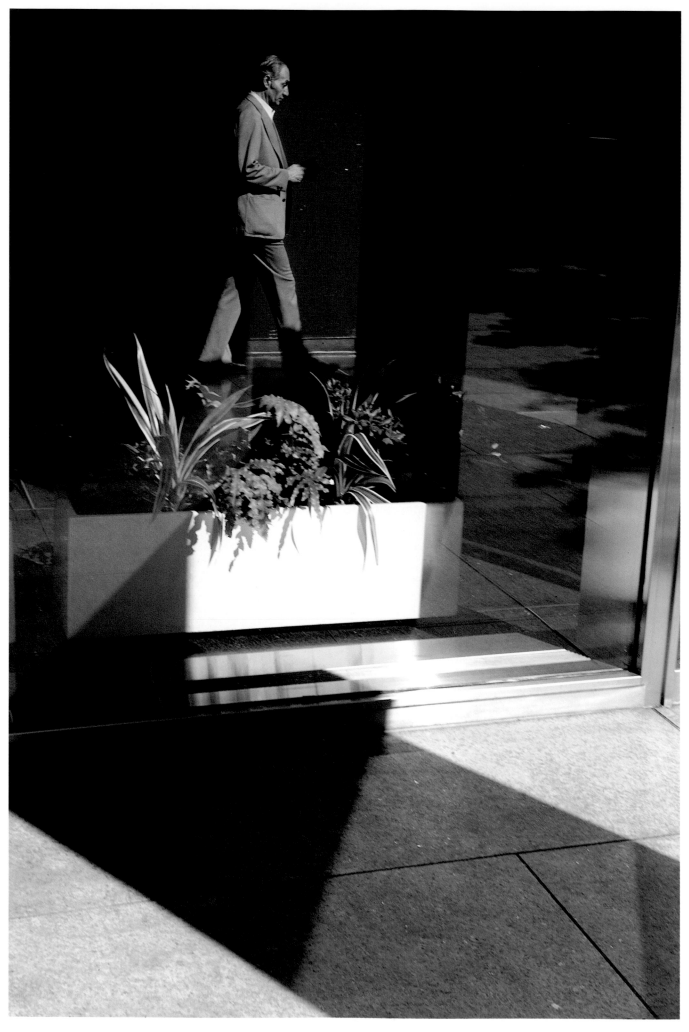

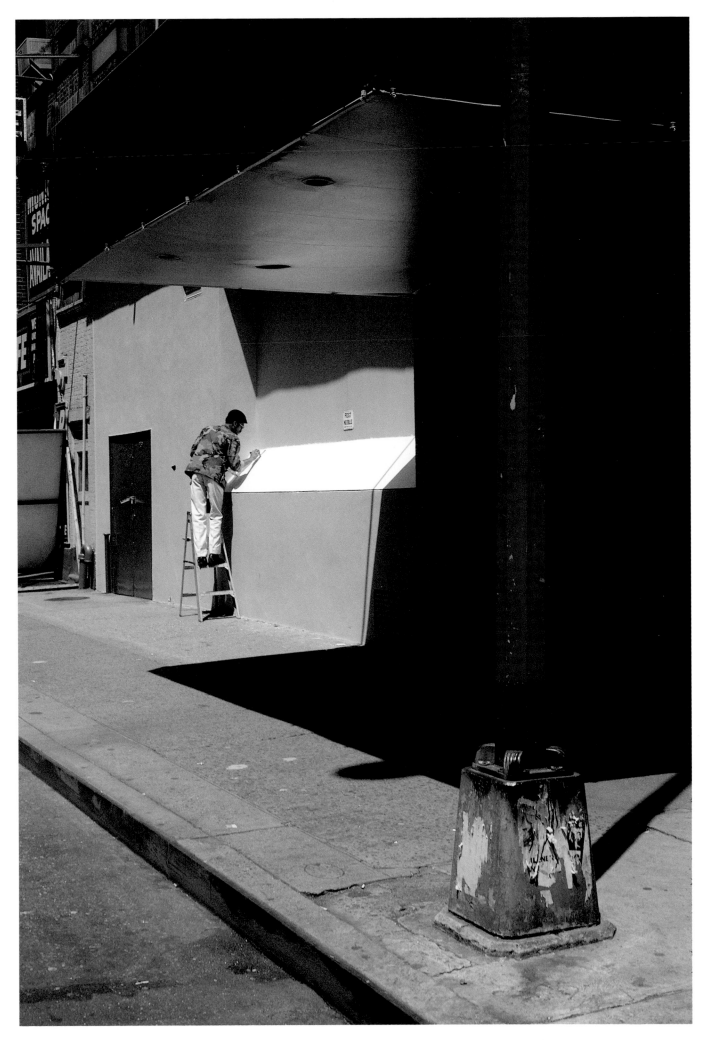

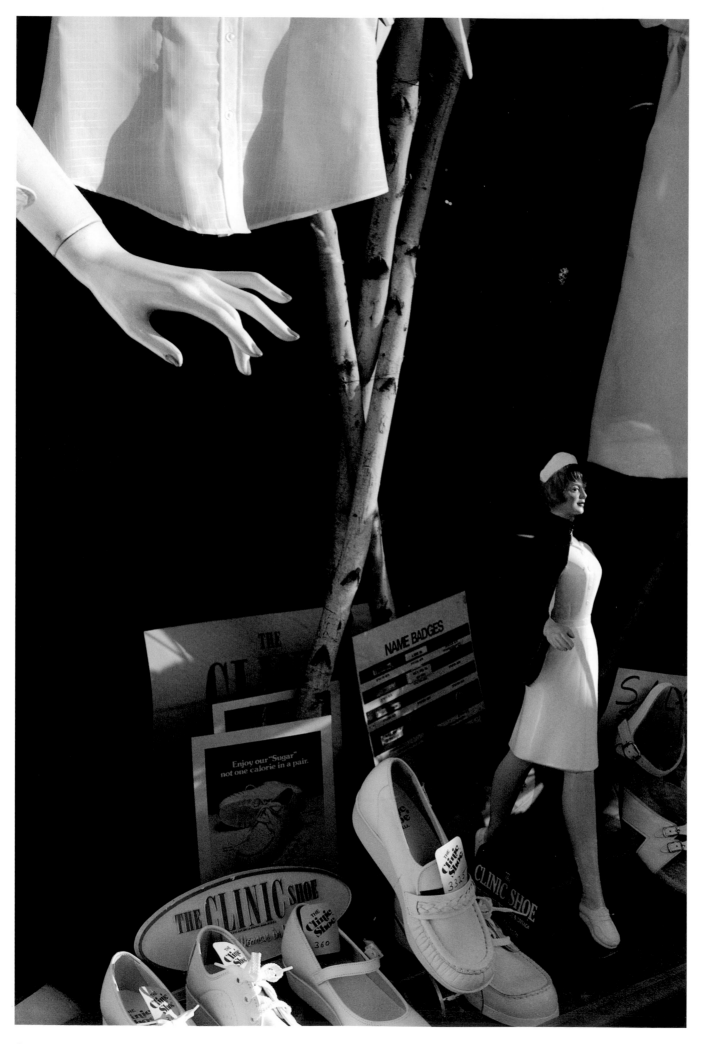

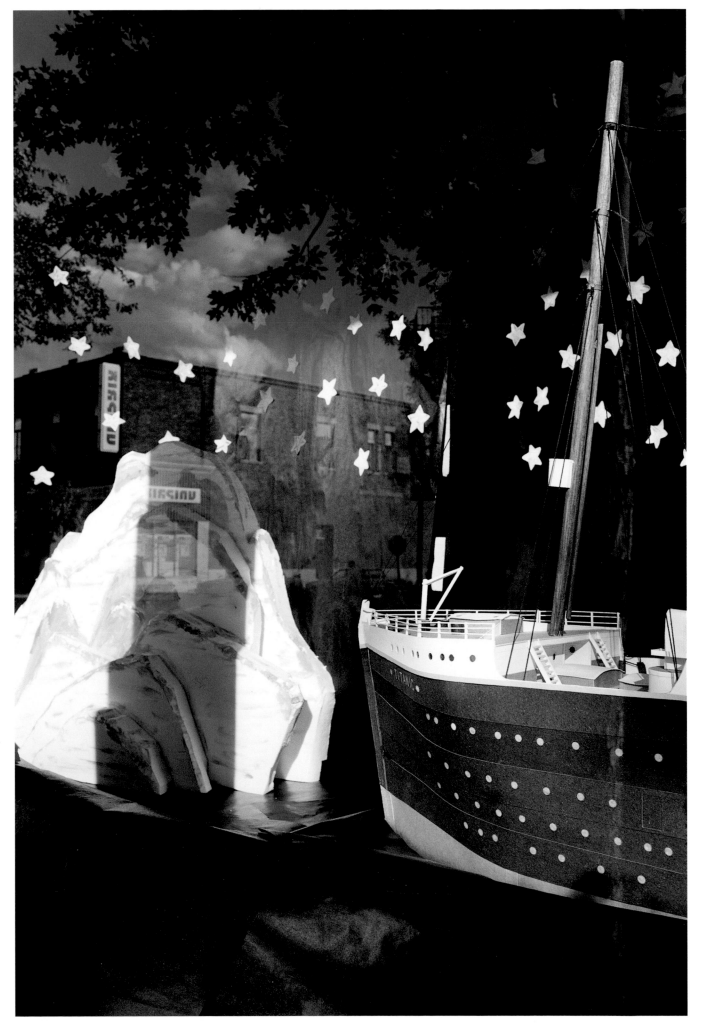

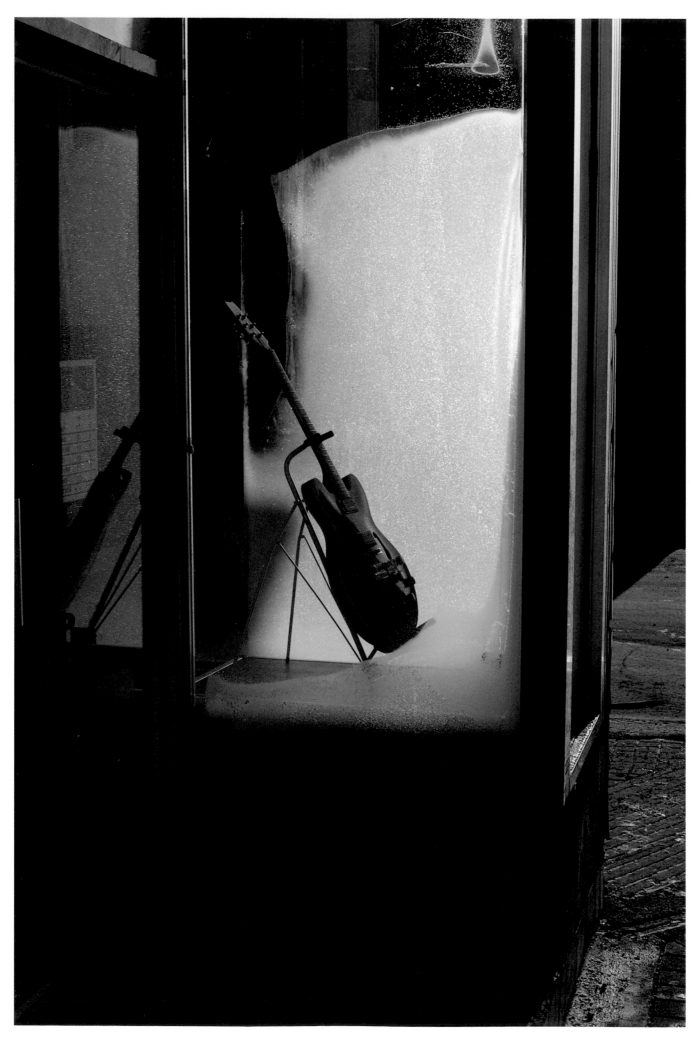

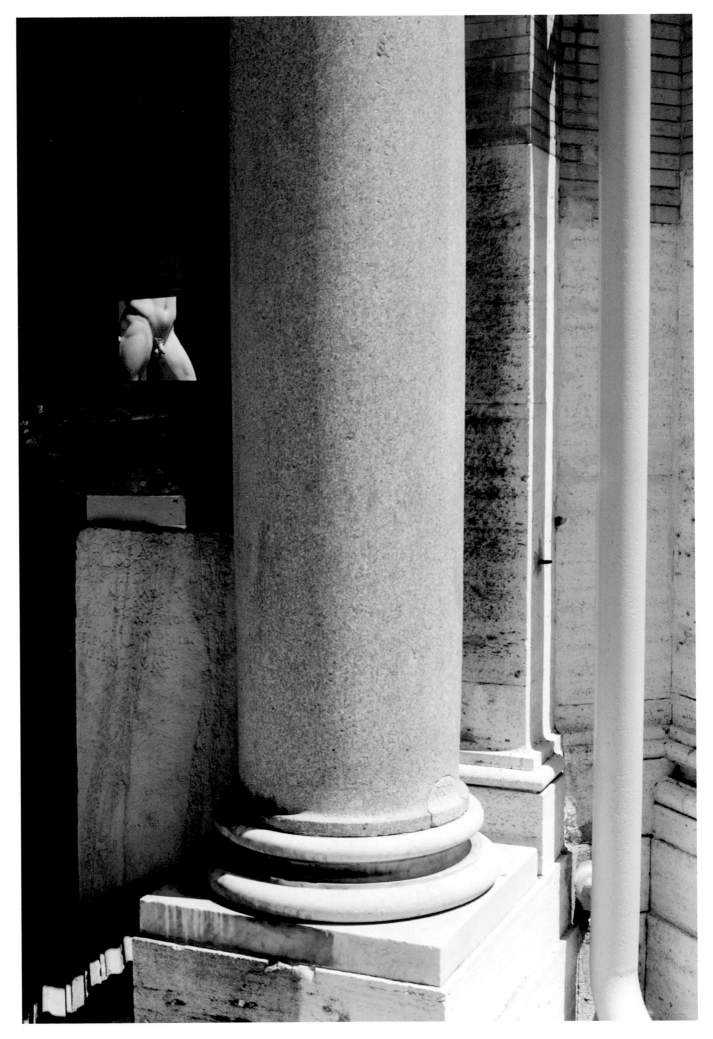

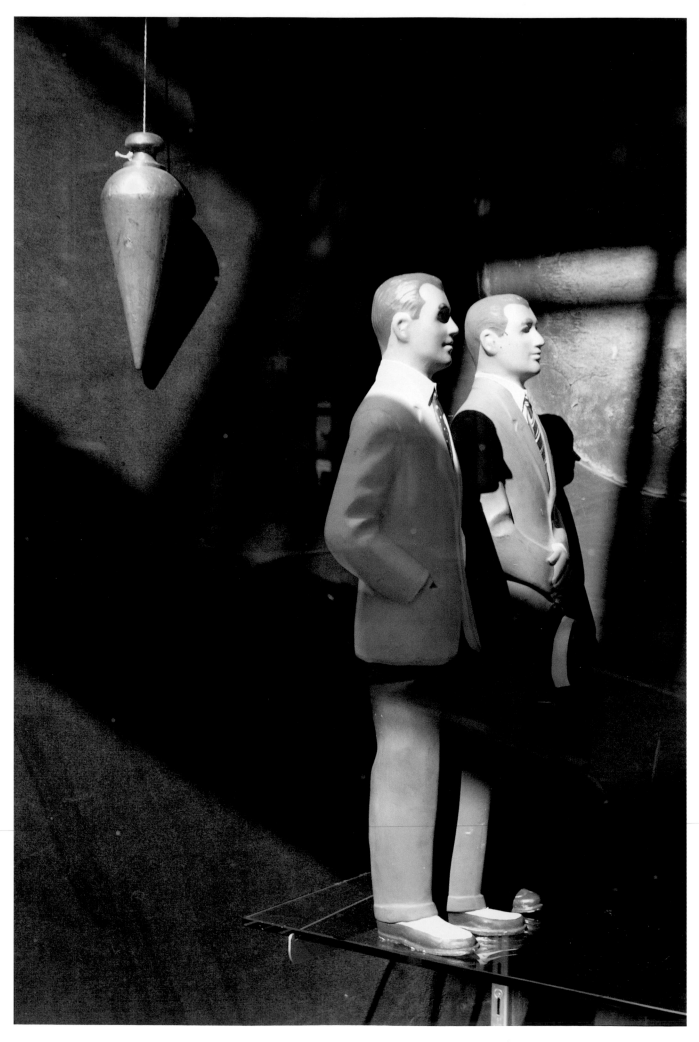

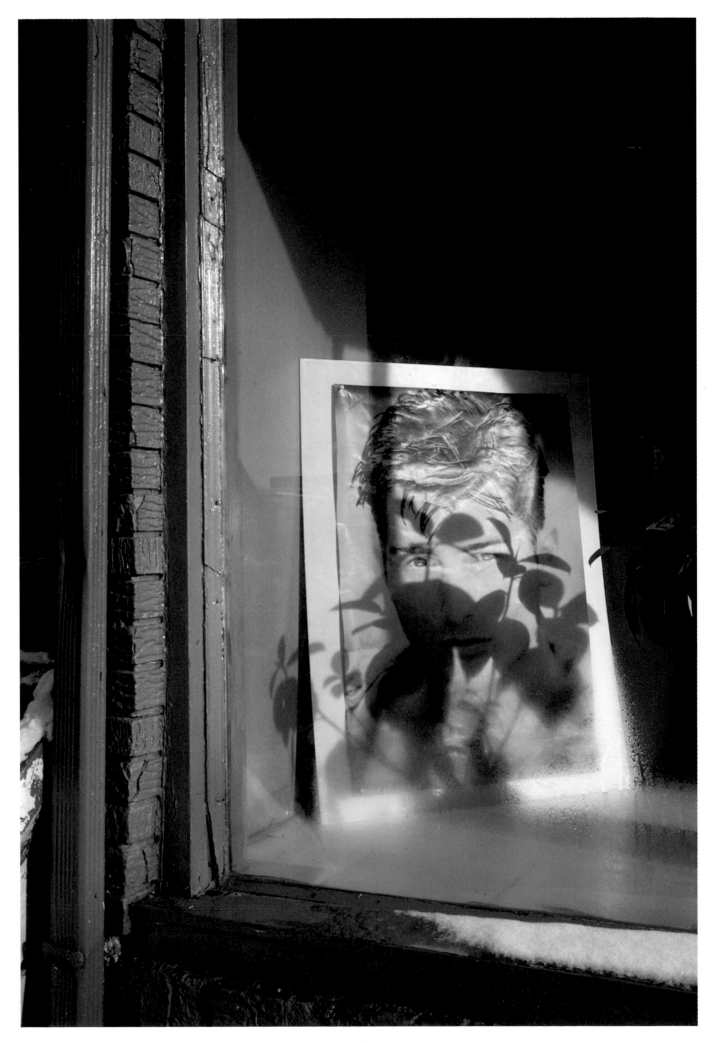

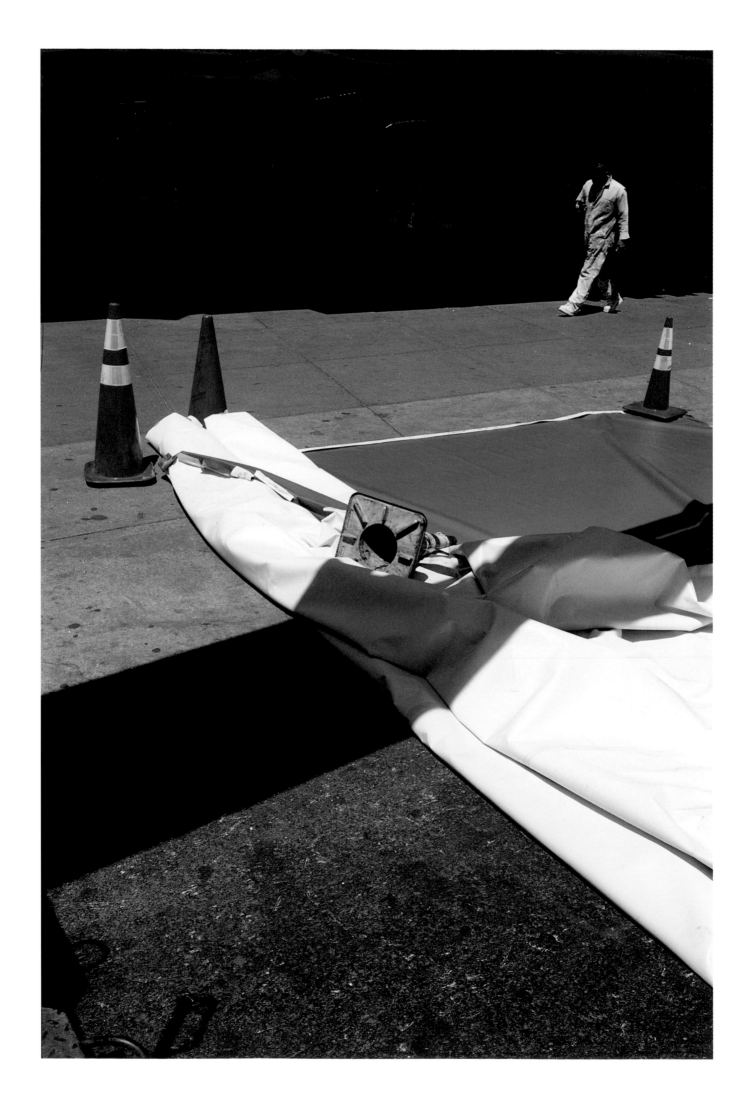

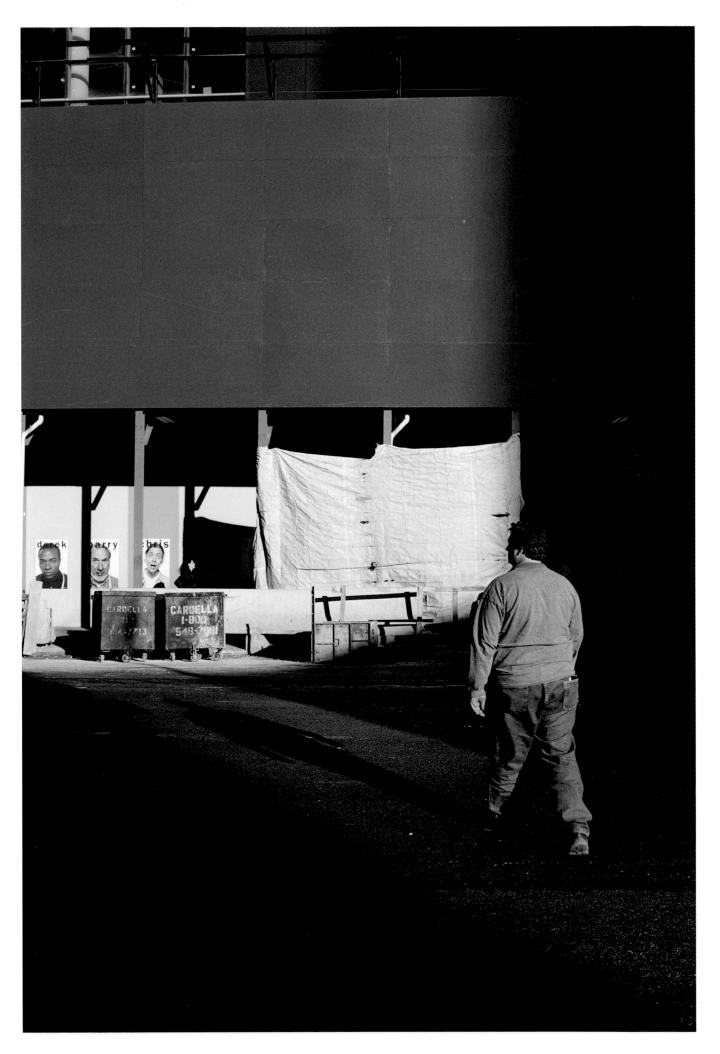

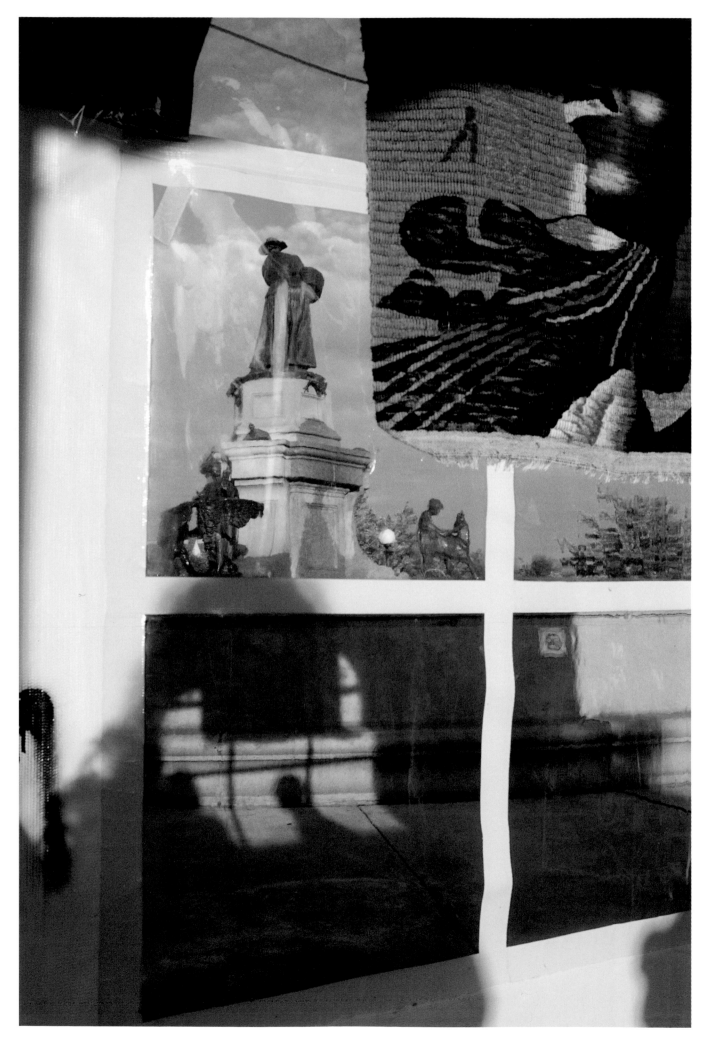

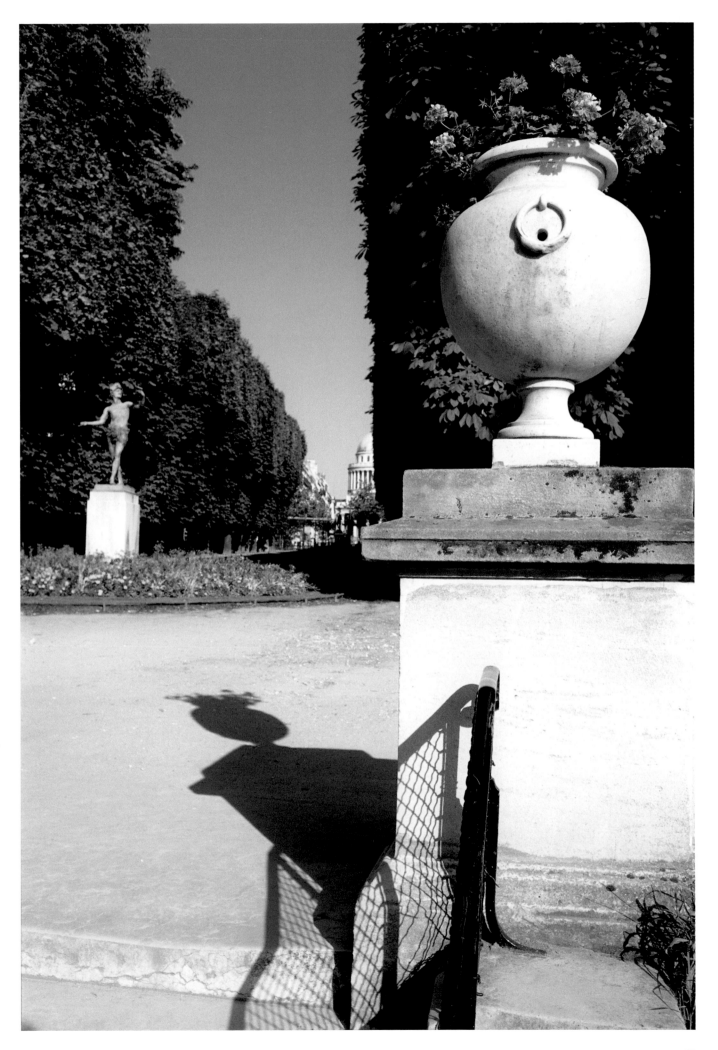

Why Search?

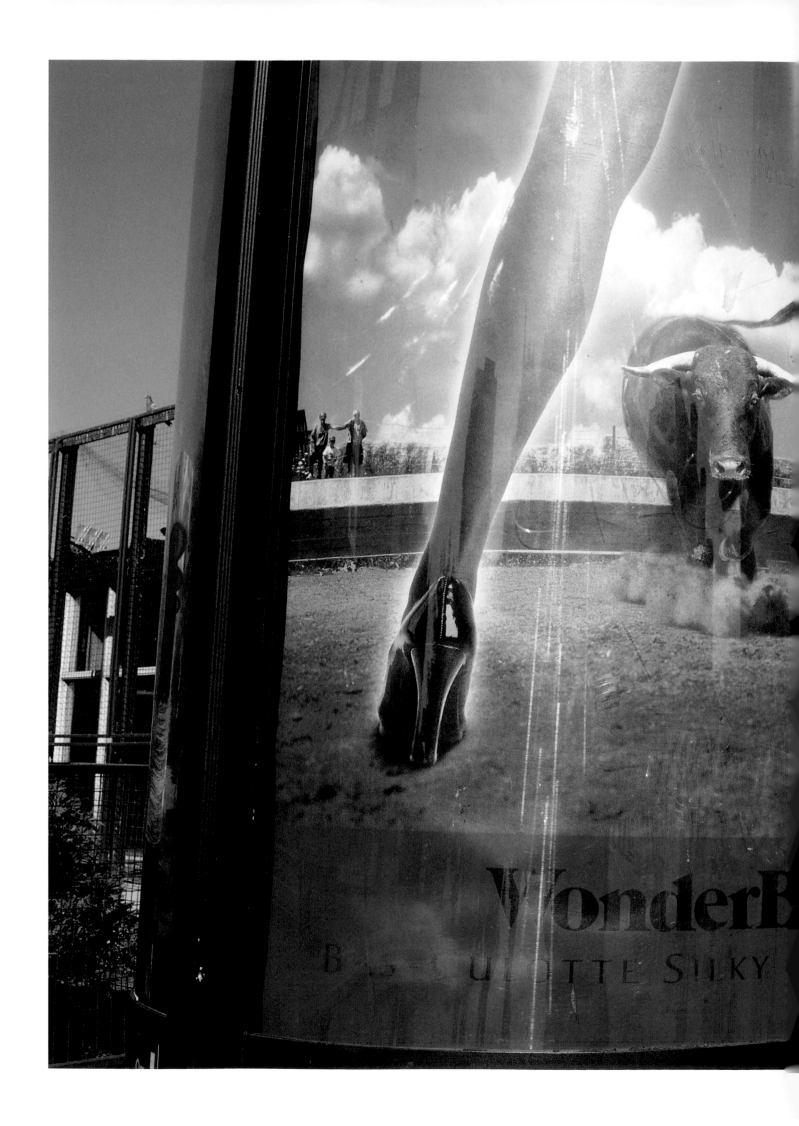

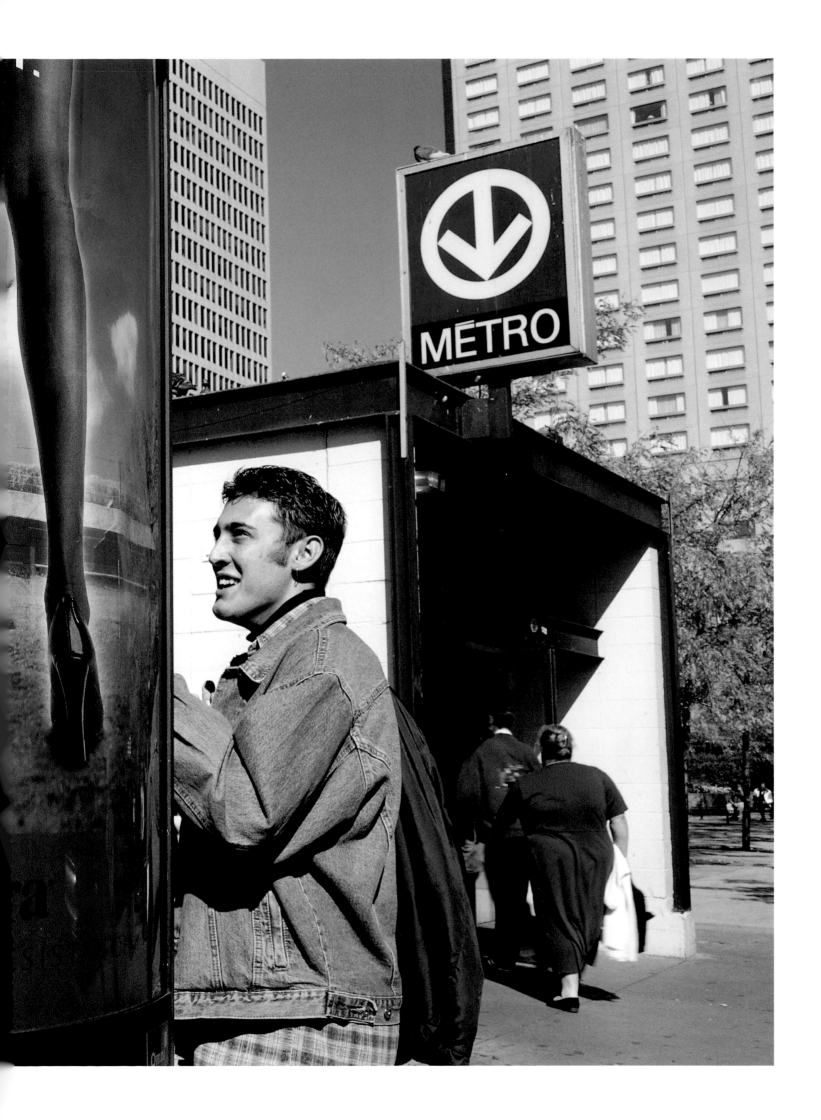

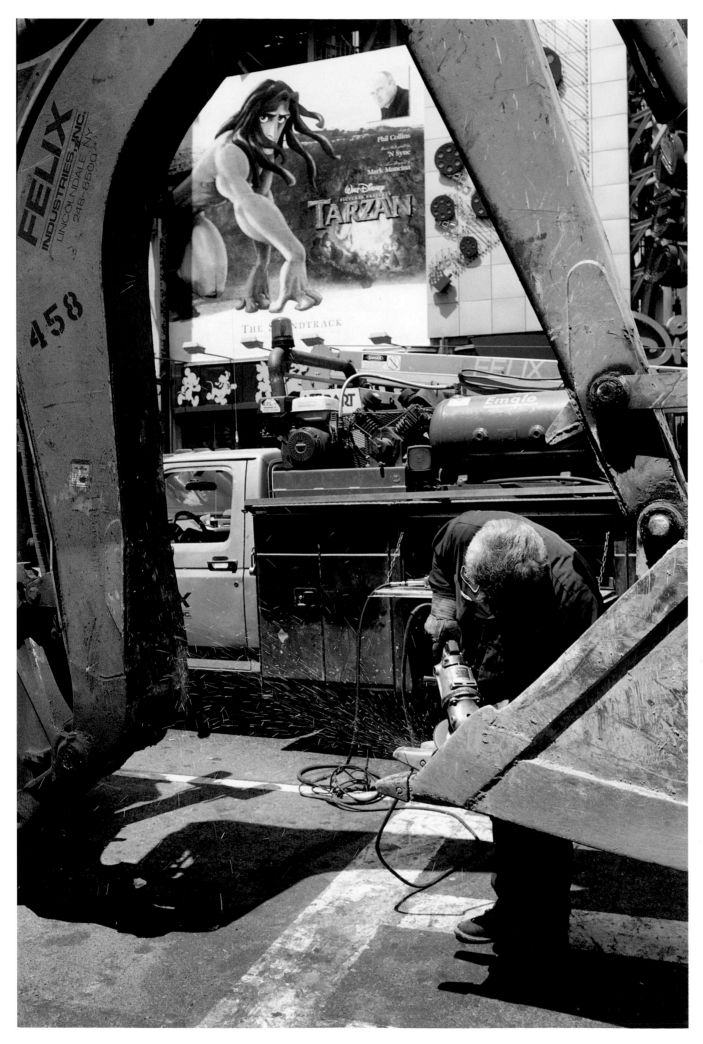

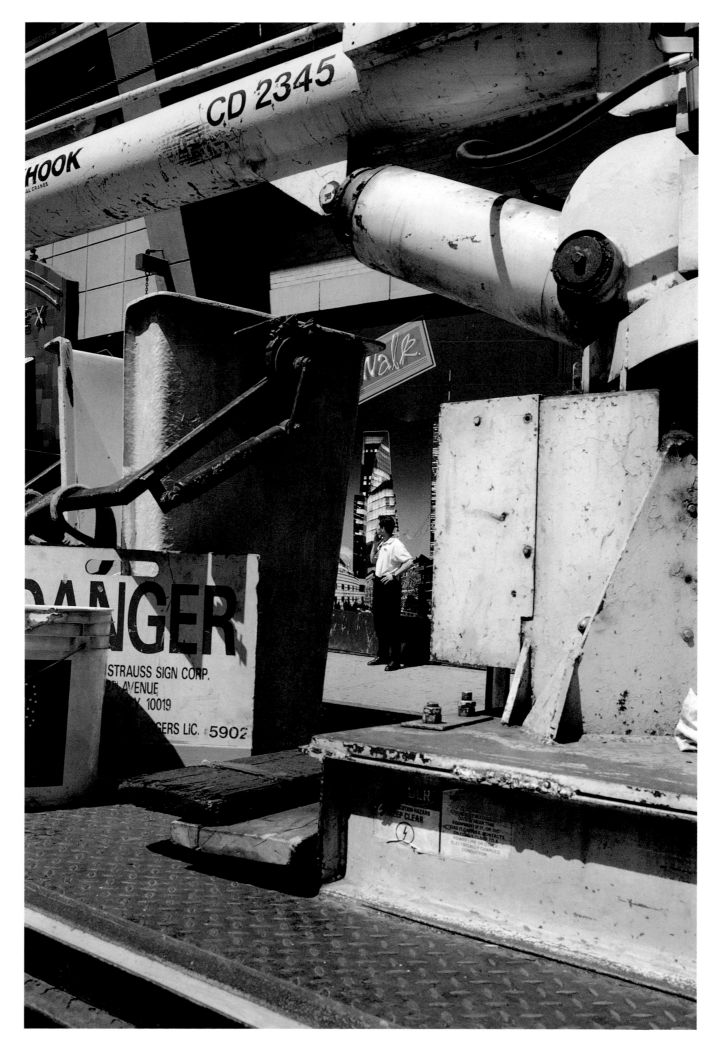

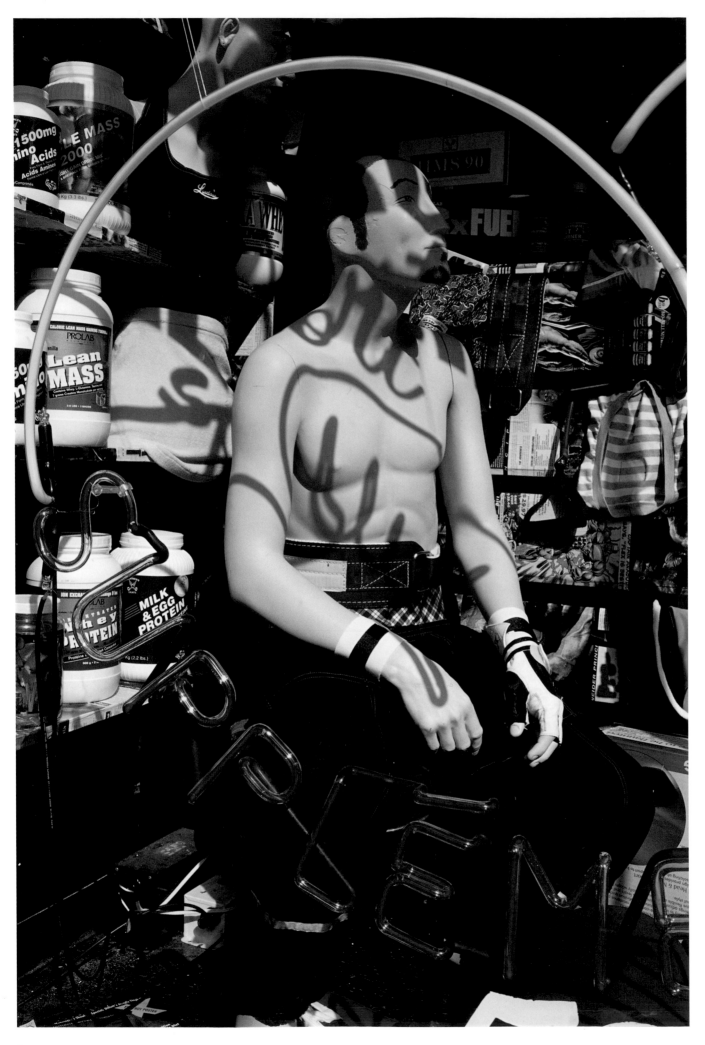

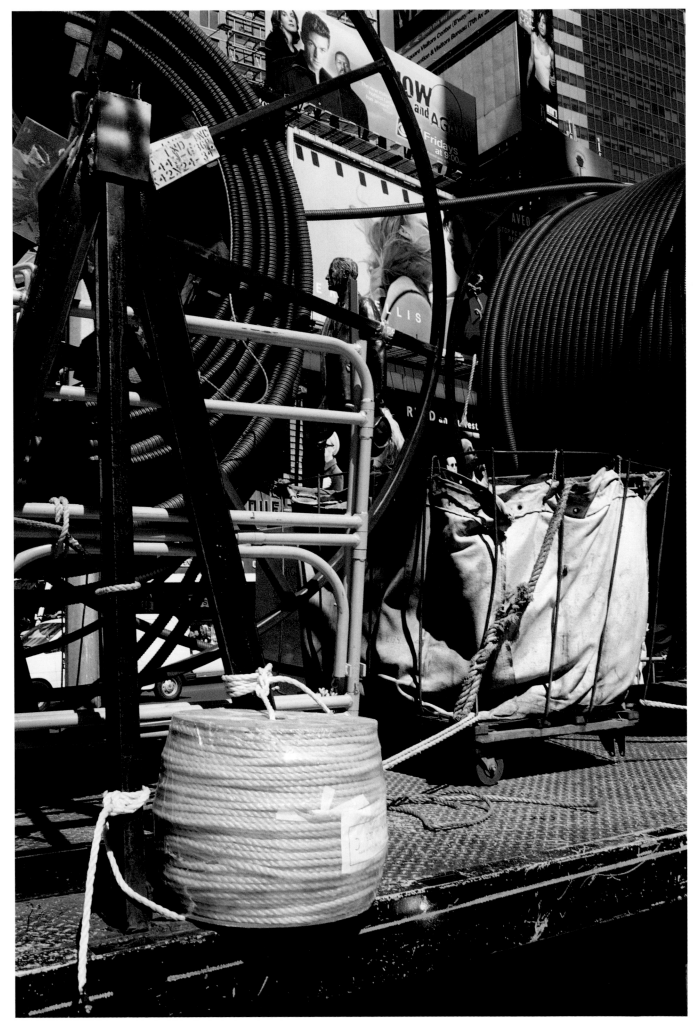

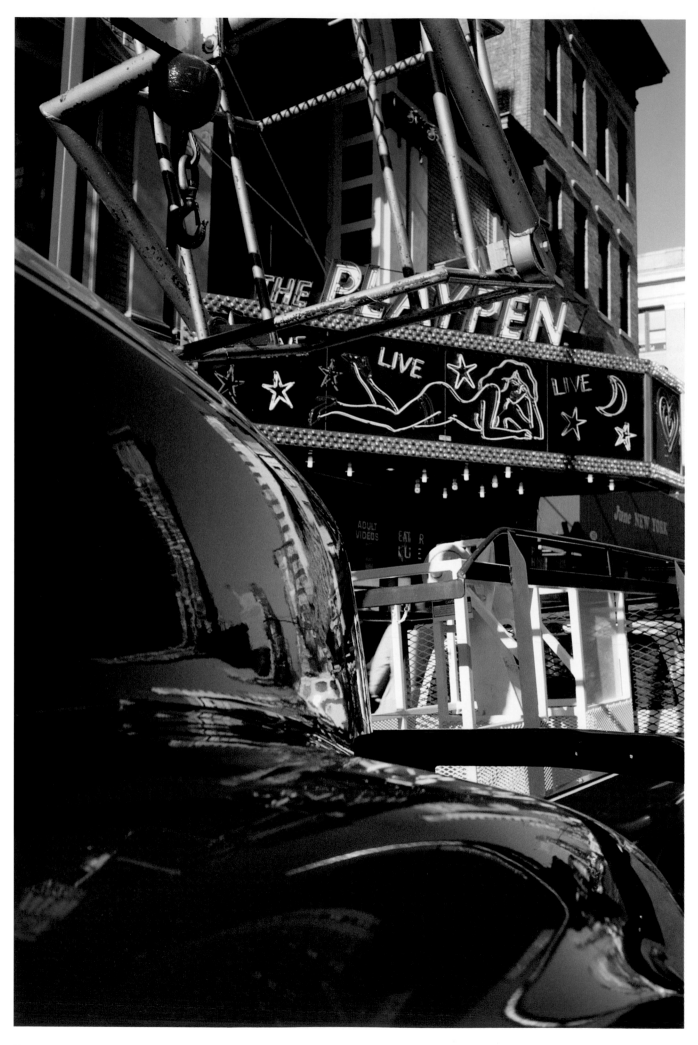

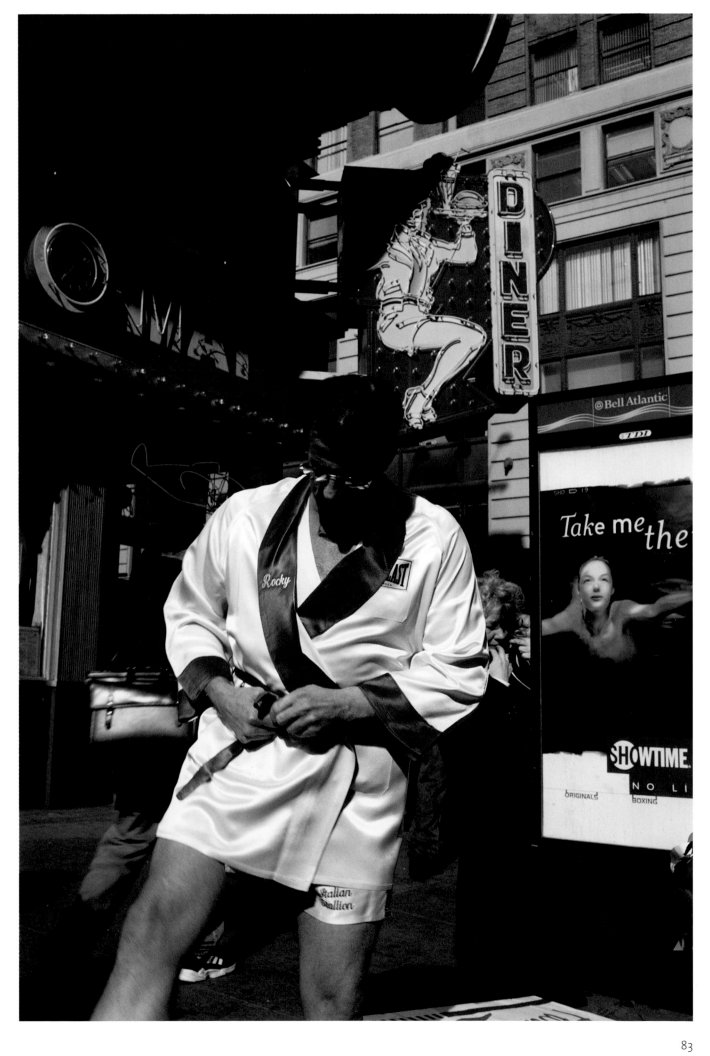

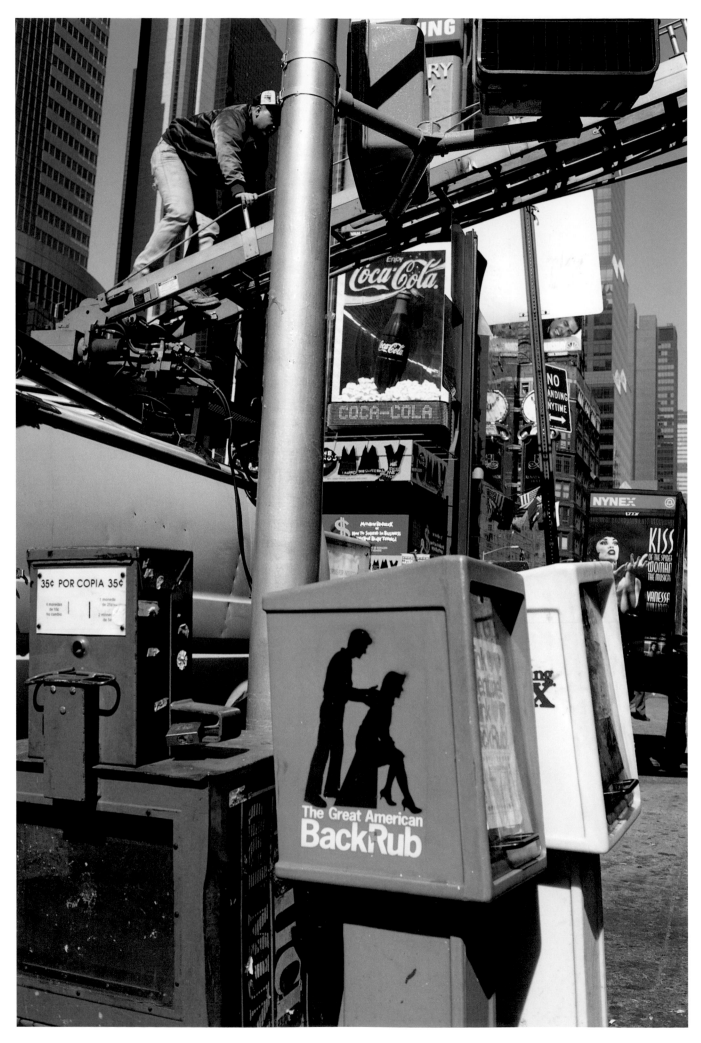

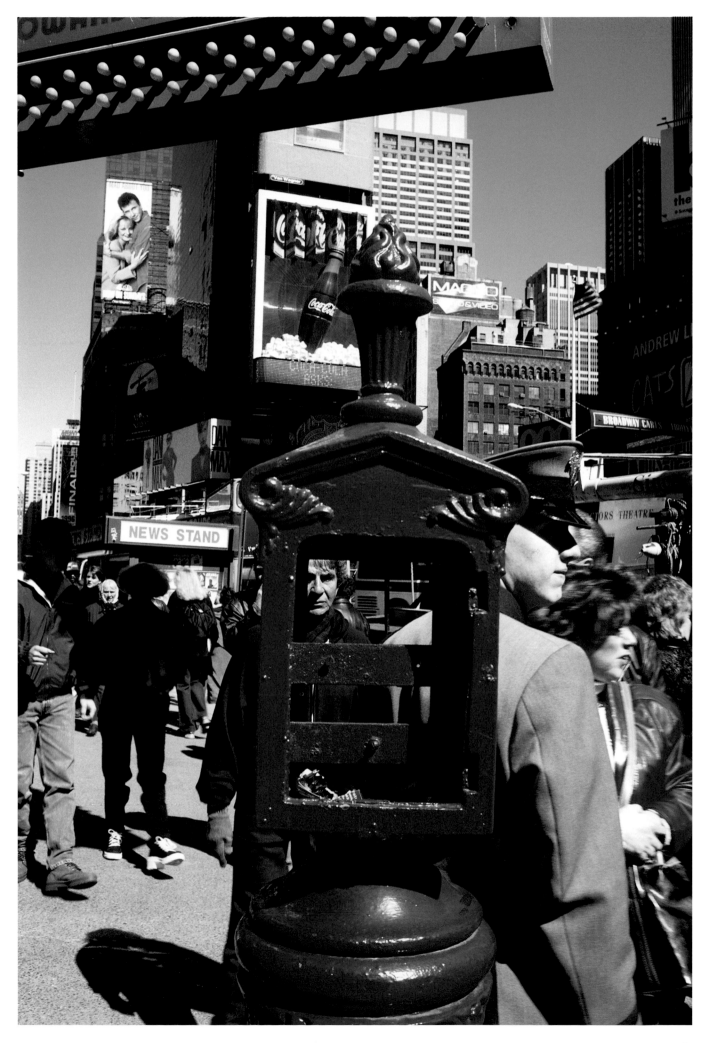

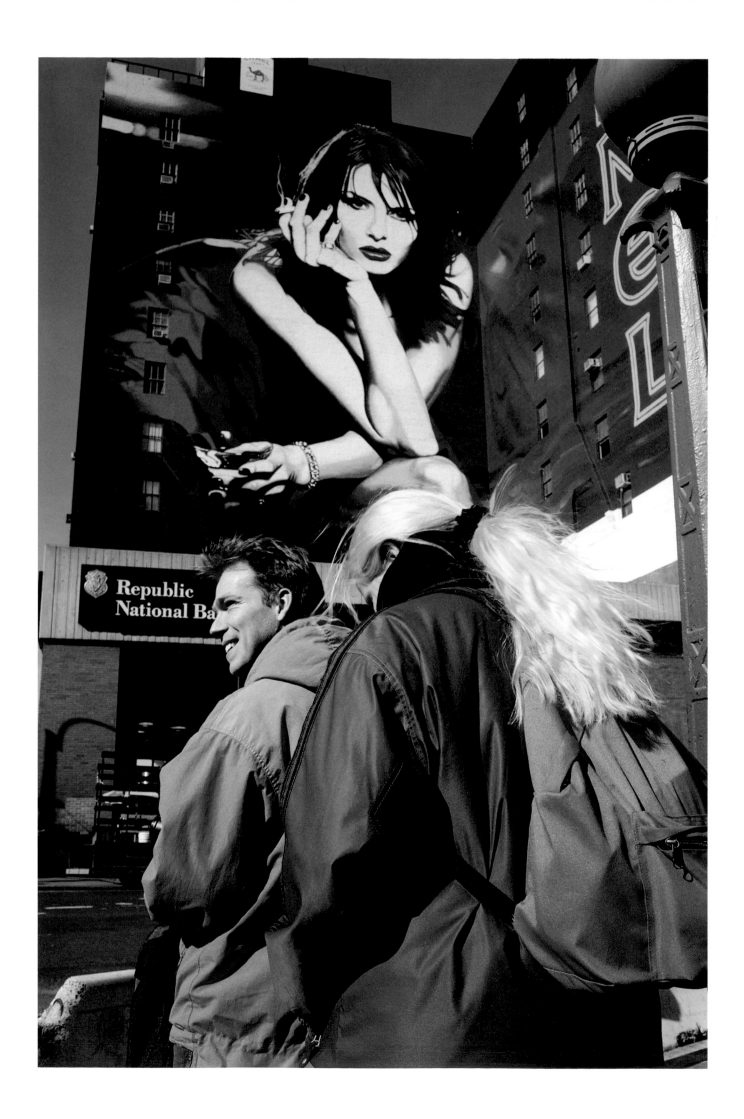

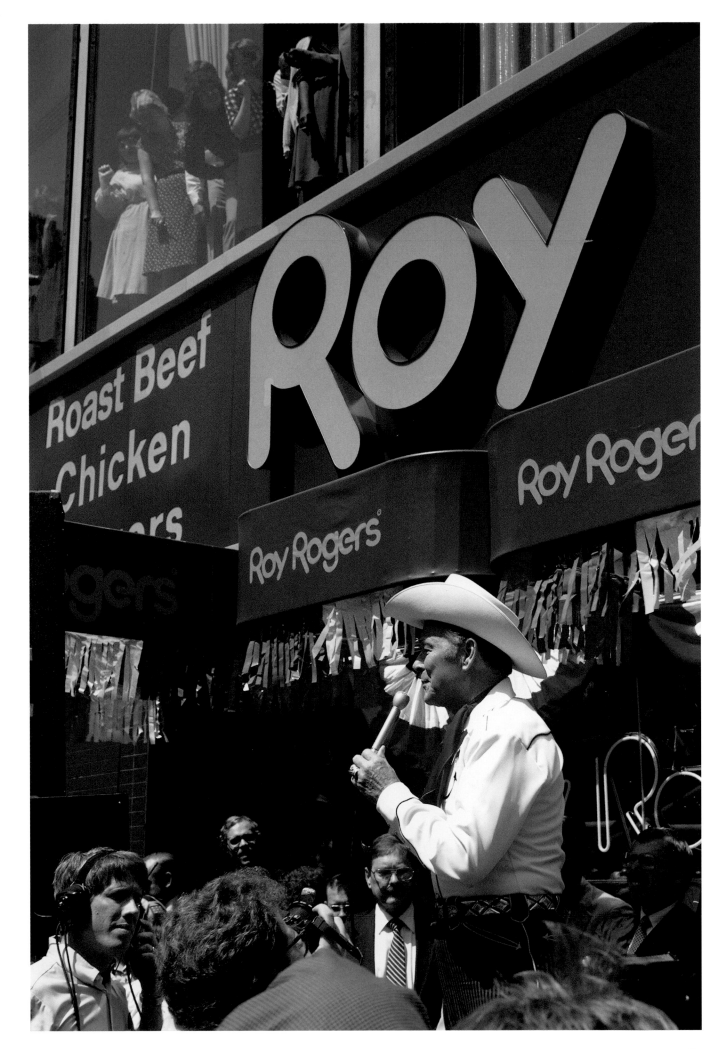

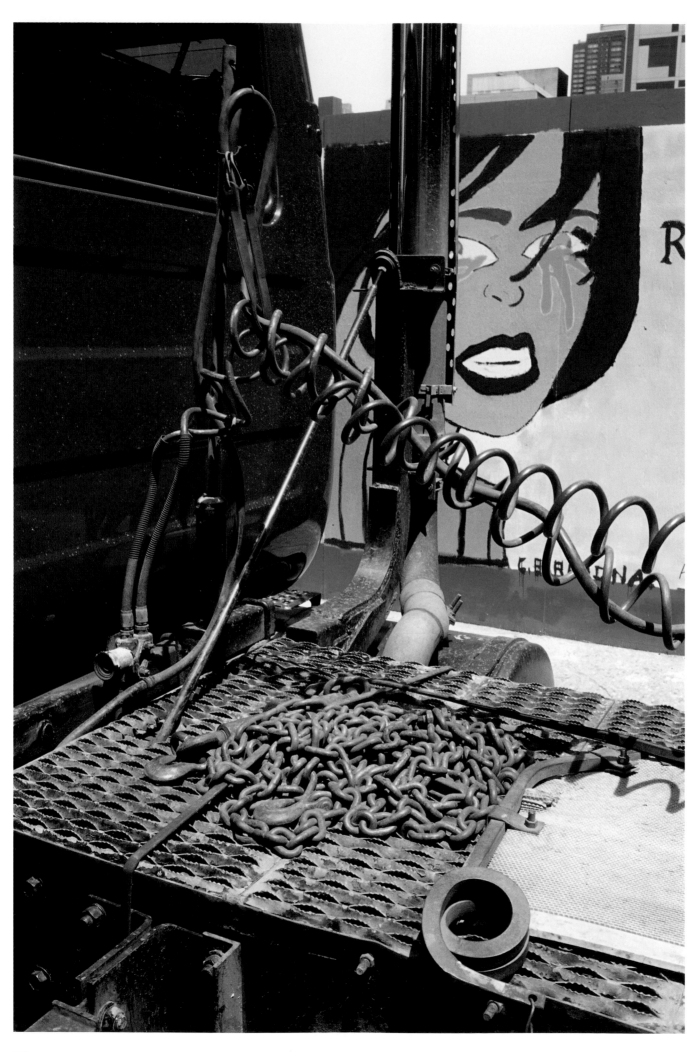

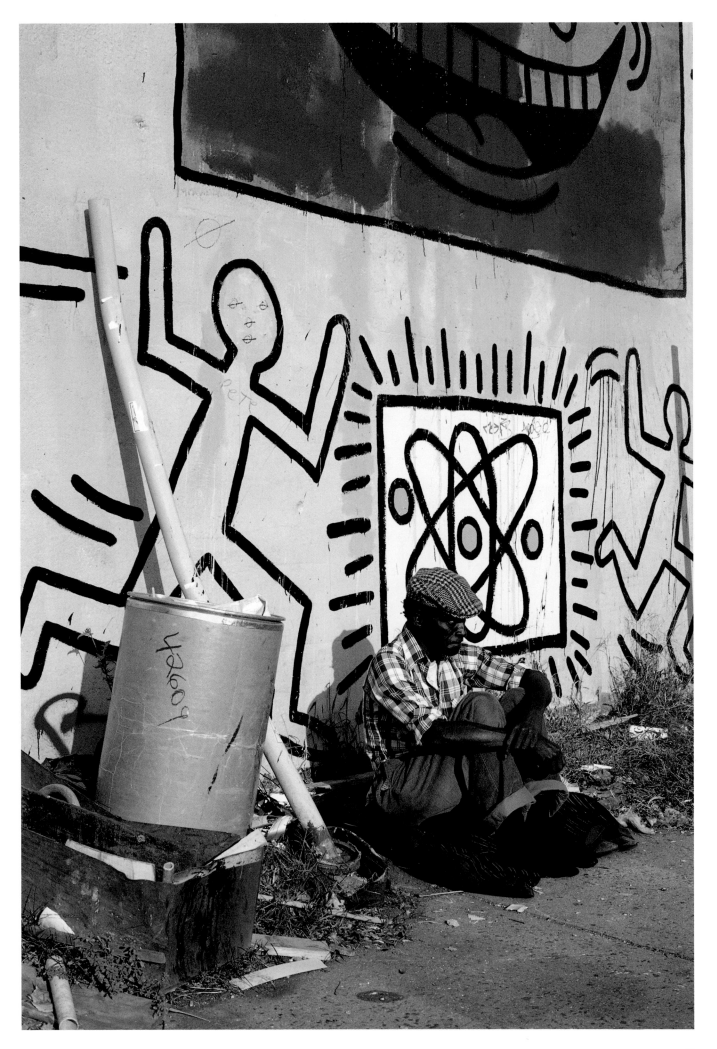

Transit Mix

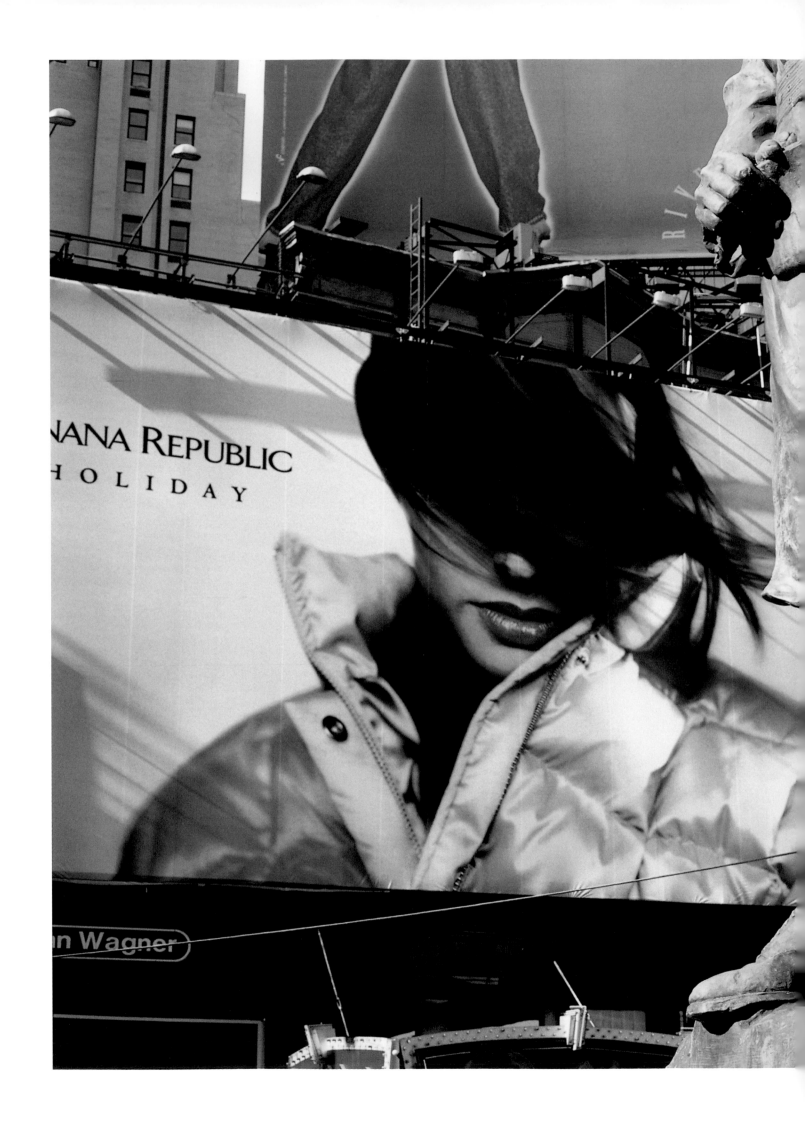

CHARLES KECK SCULPTOR 1936

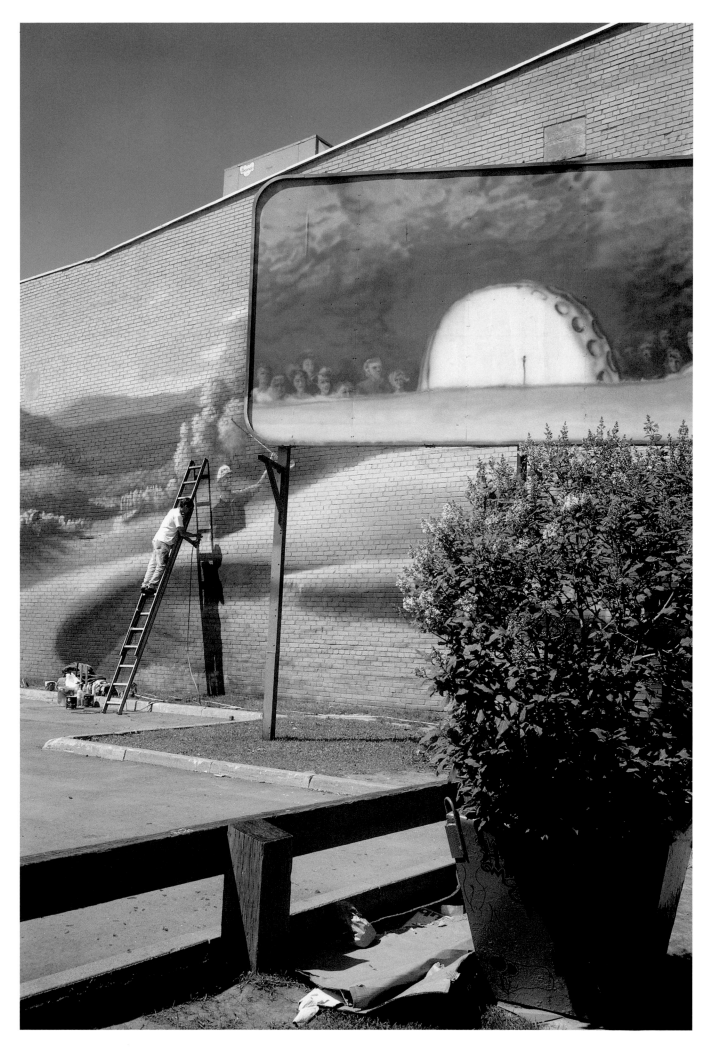

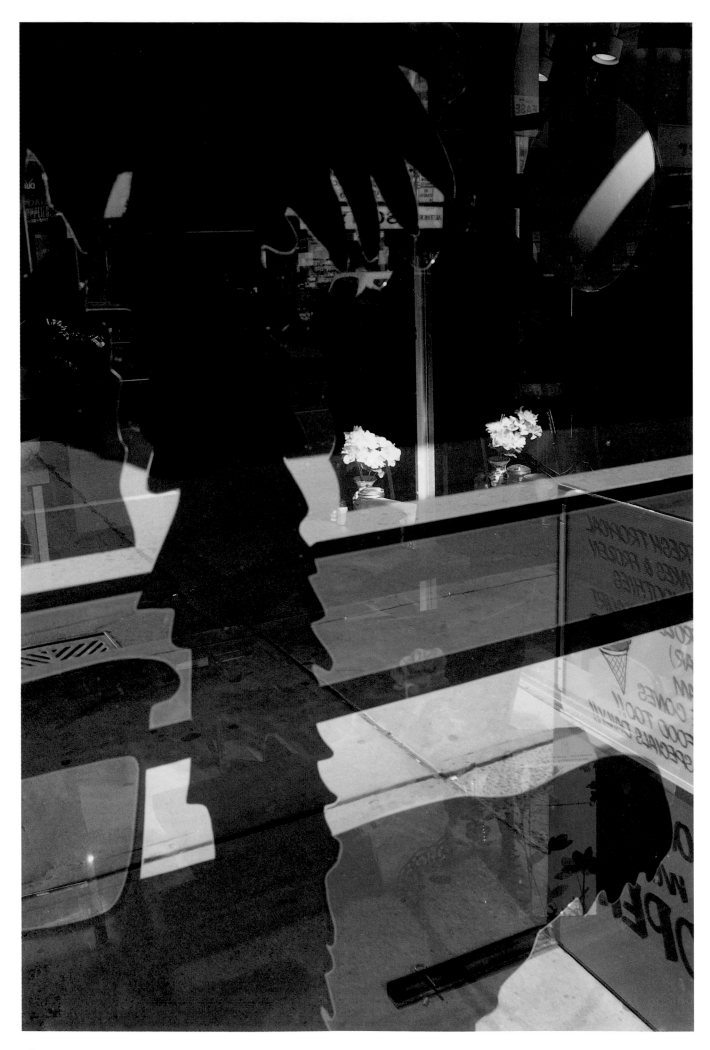

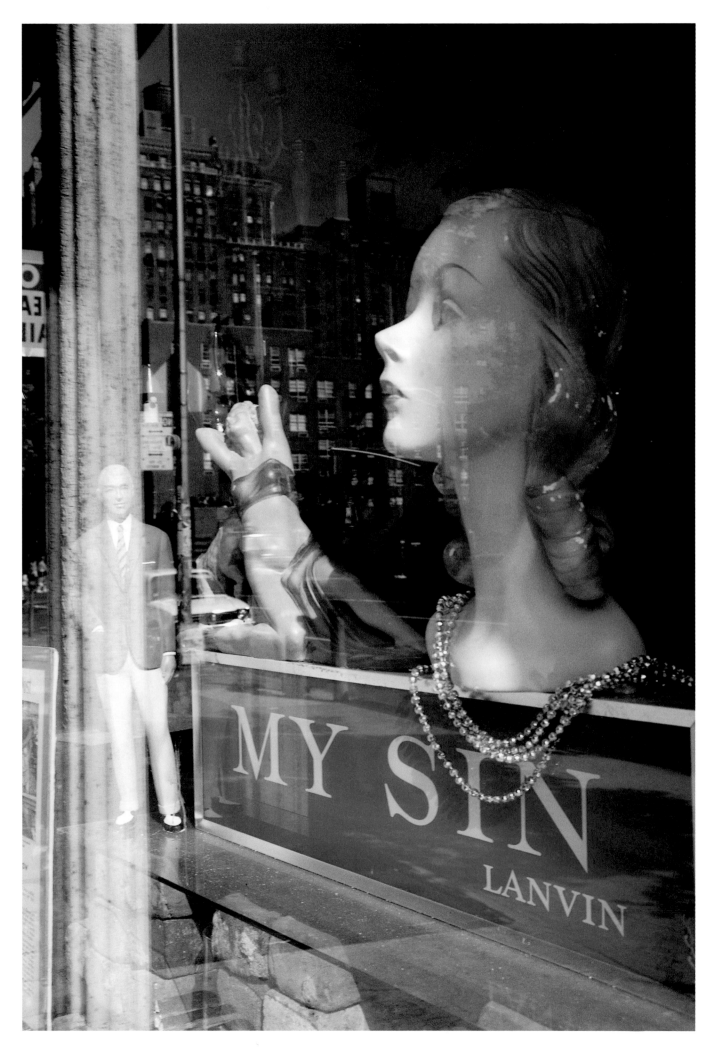

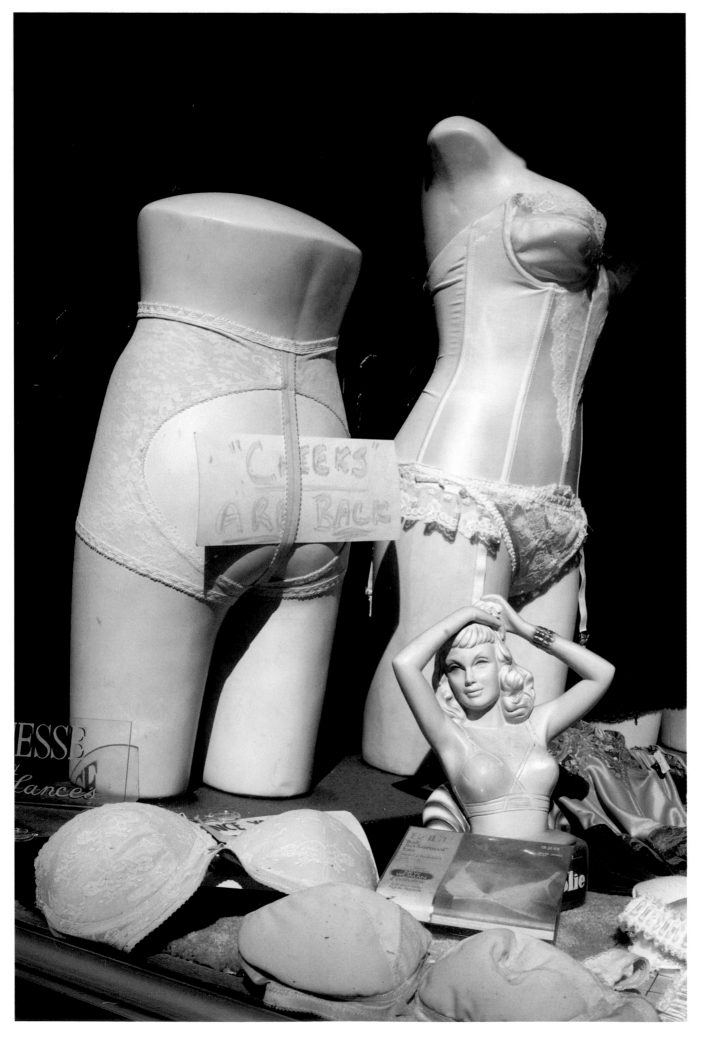

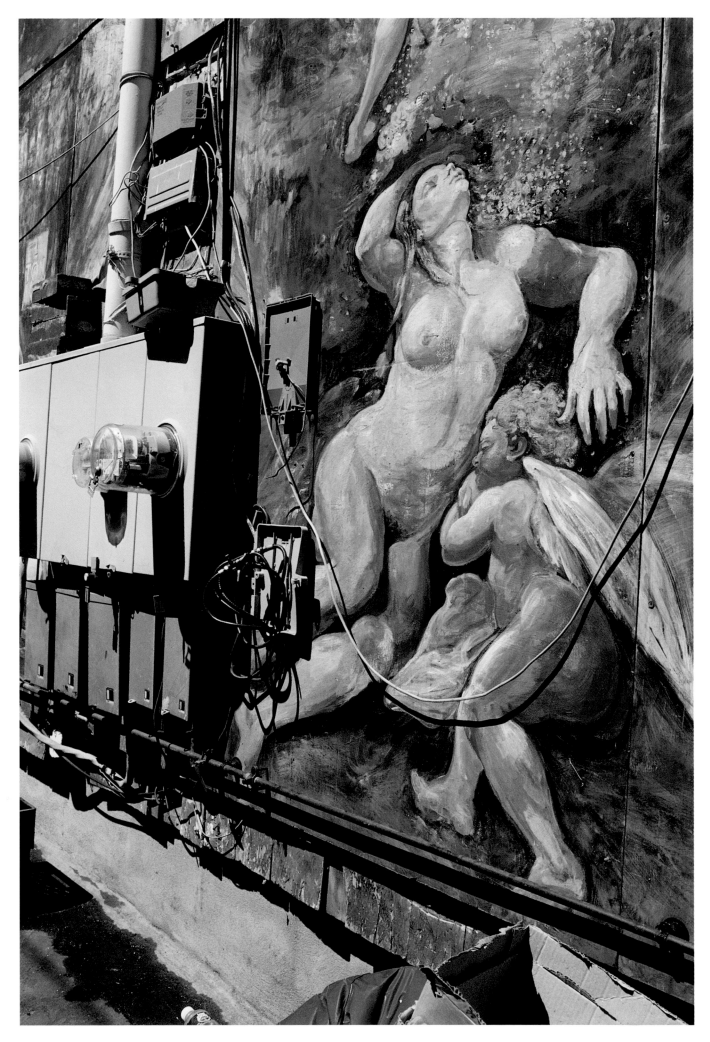

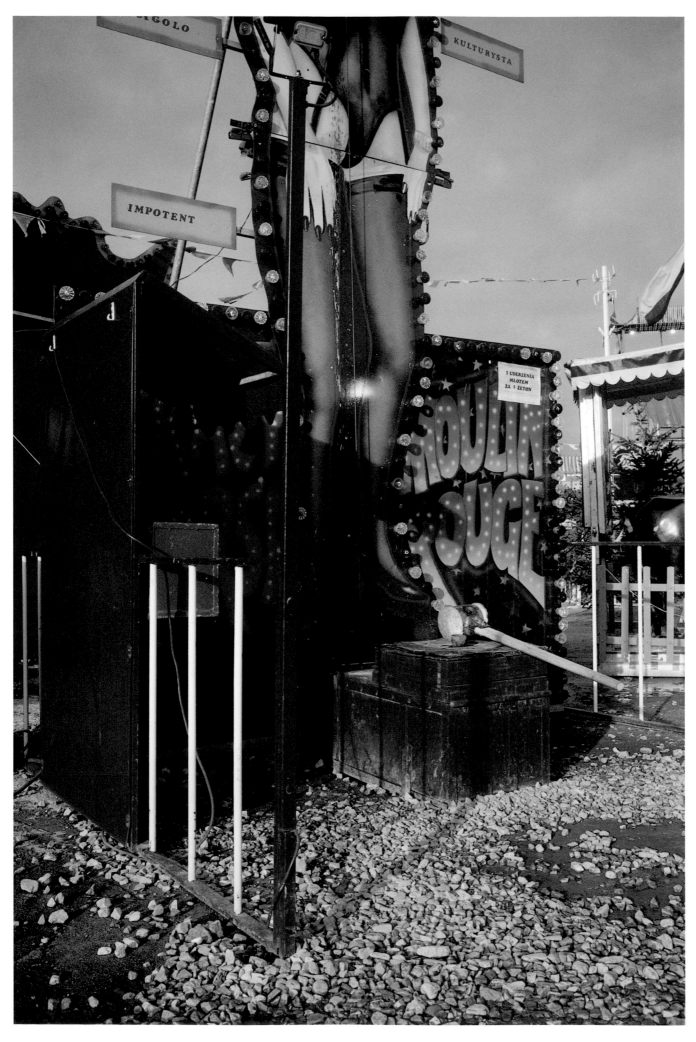

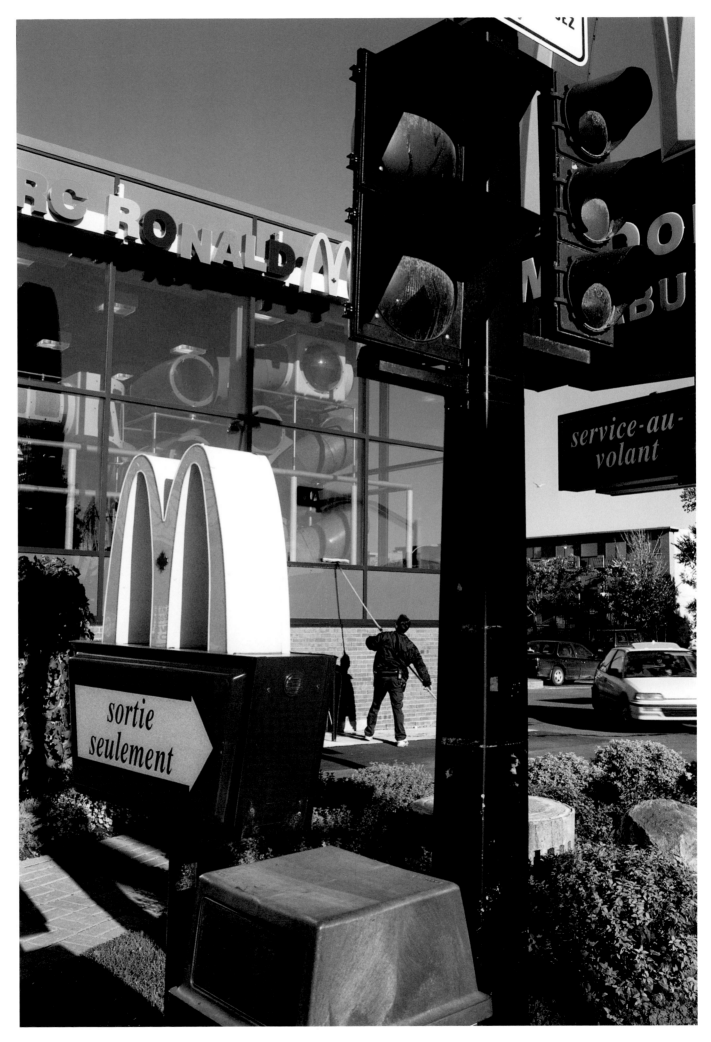

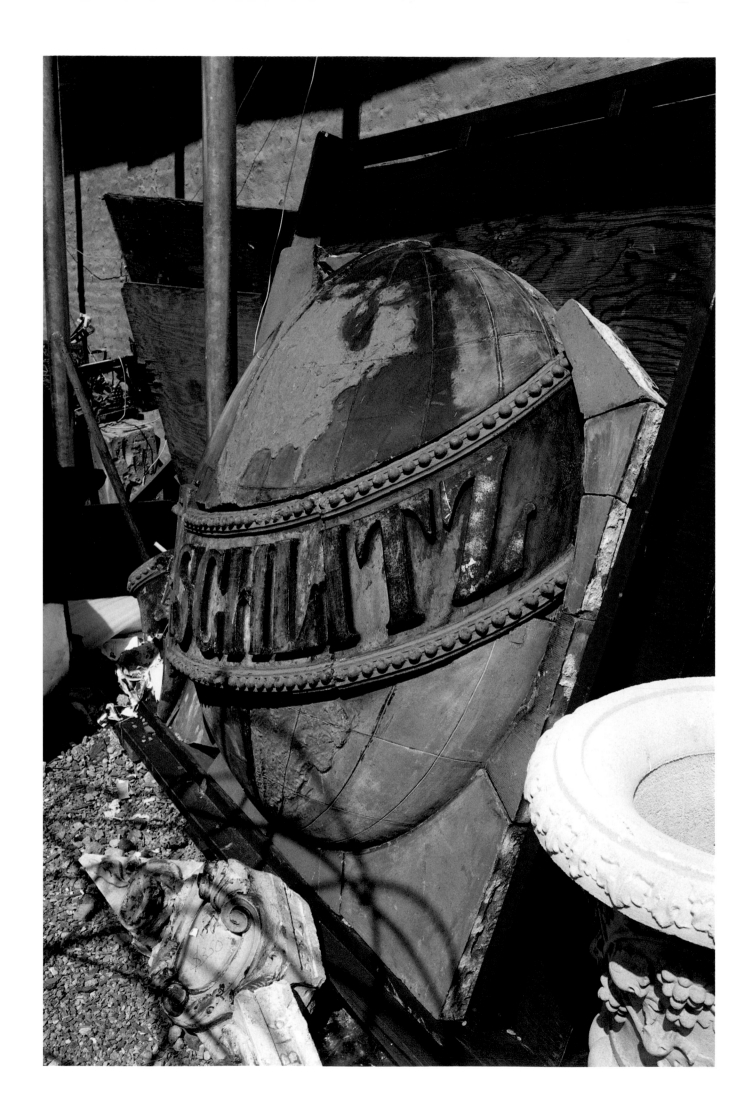

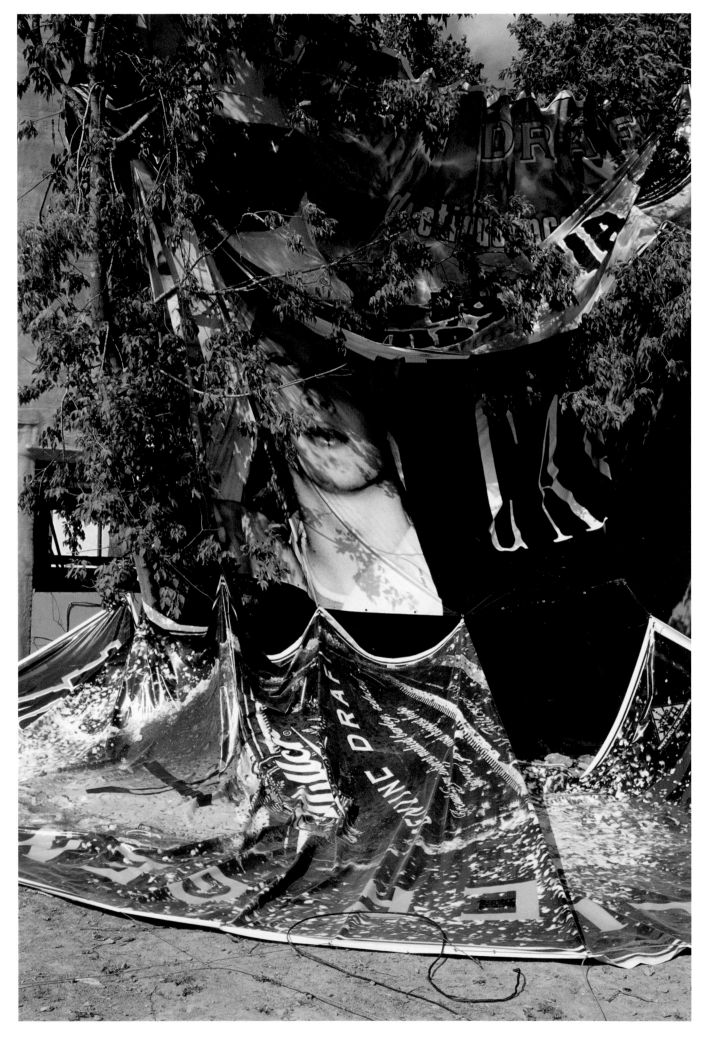

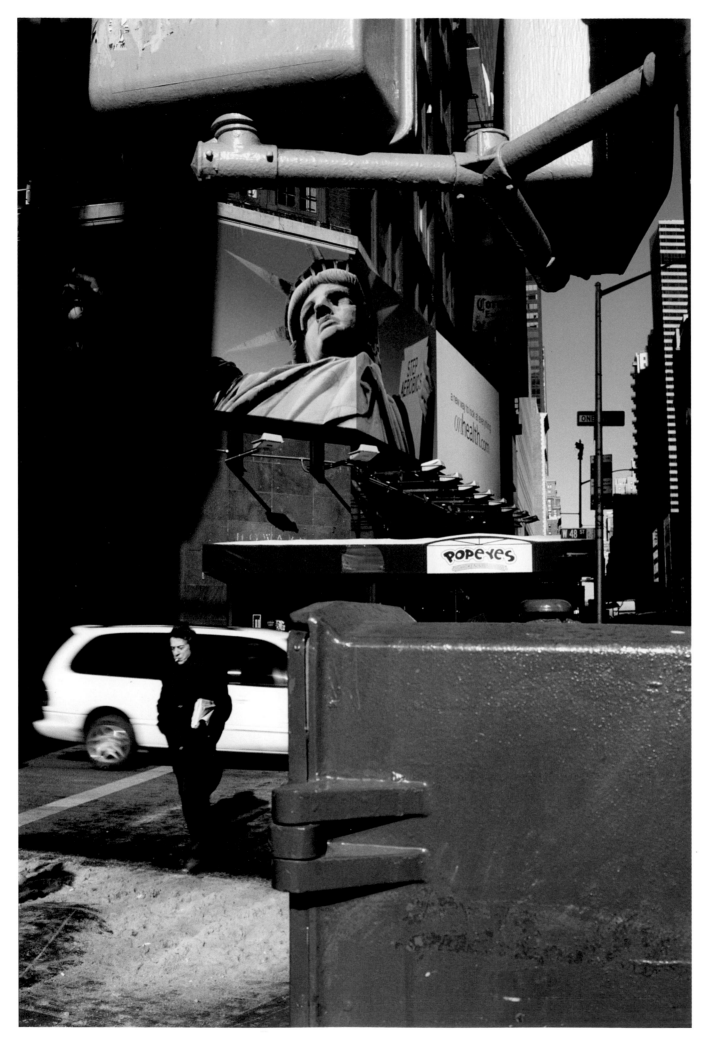

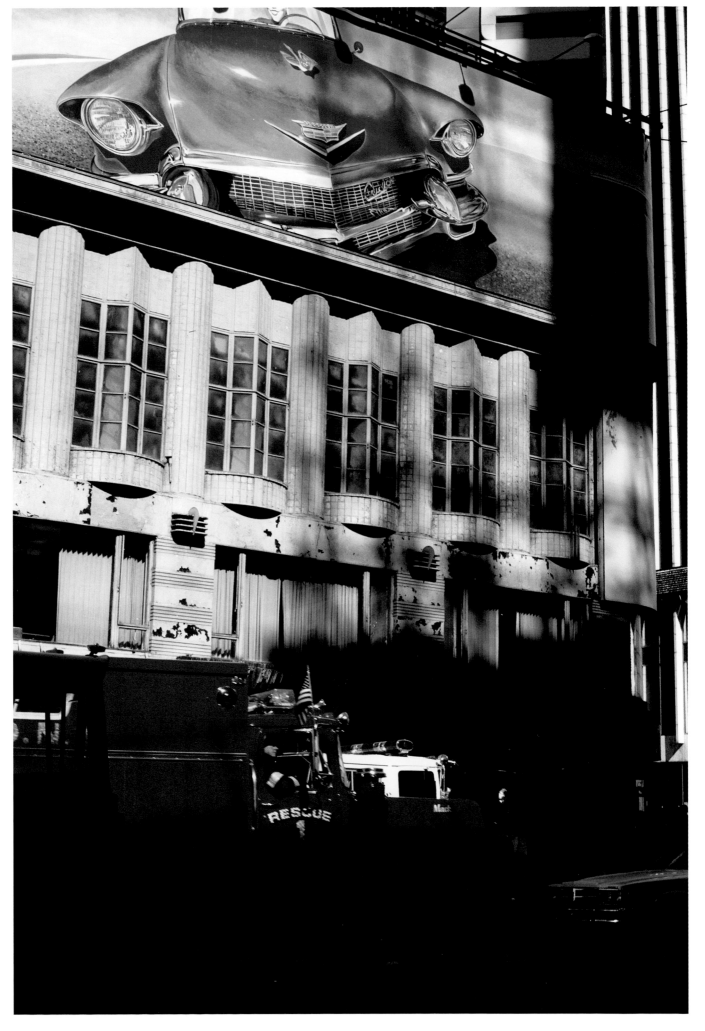

Psychic Reading

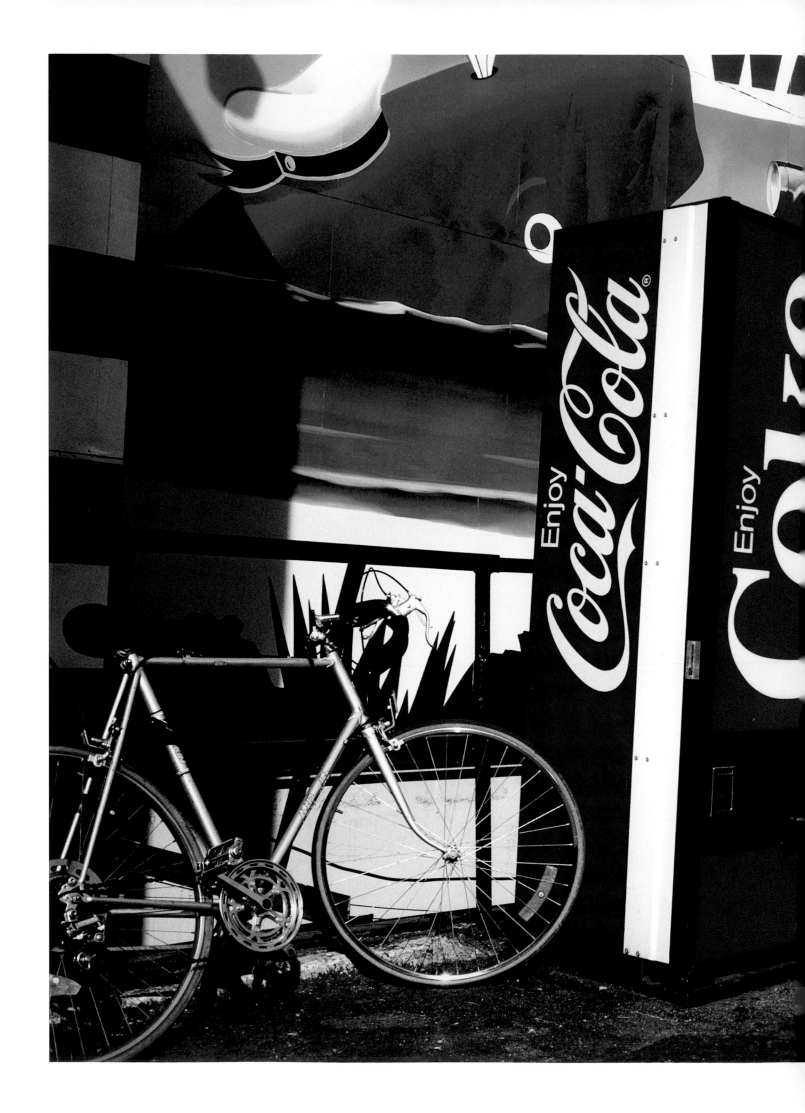

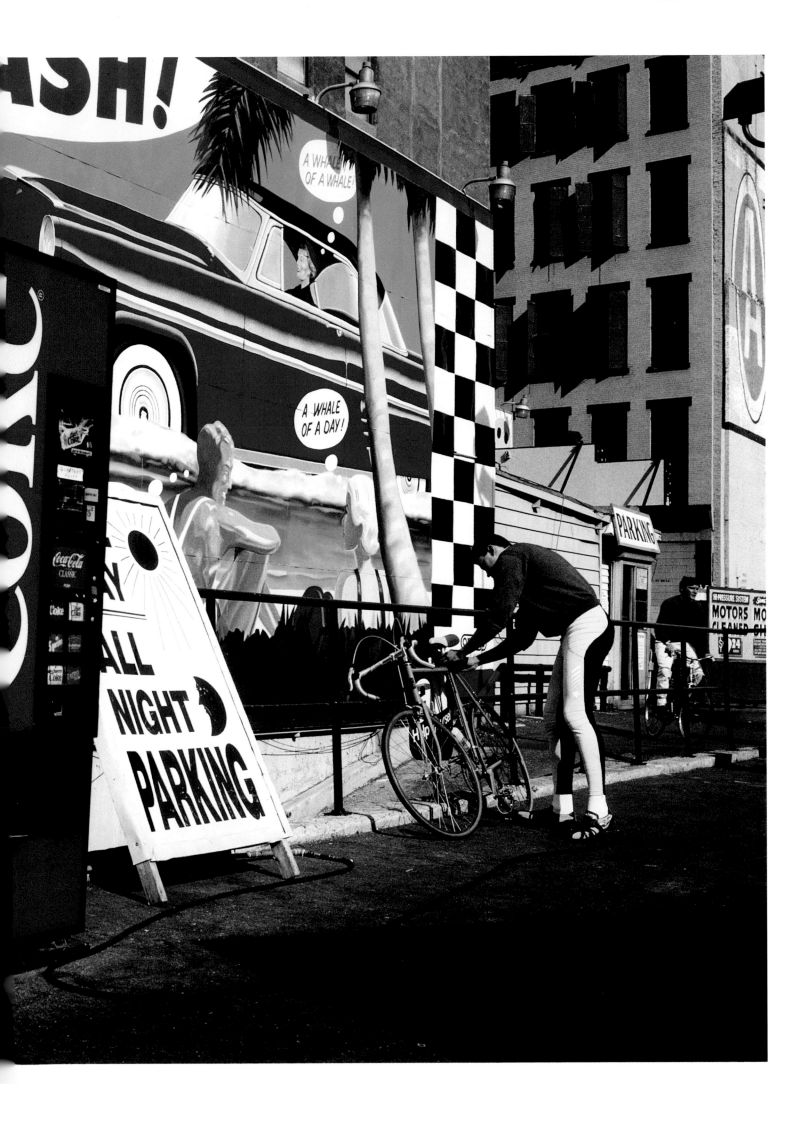

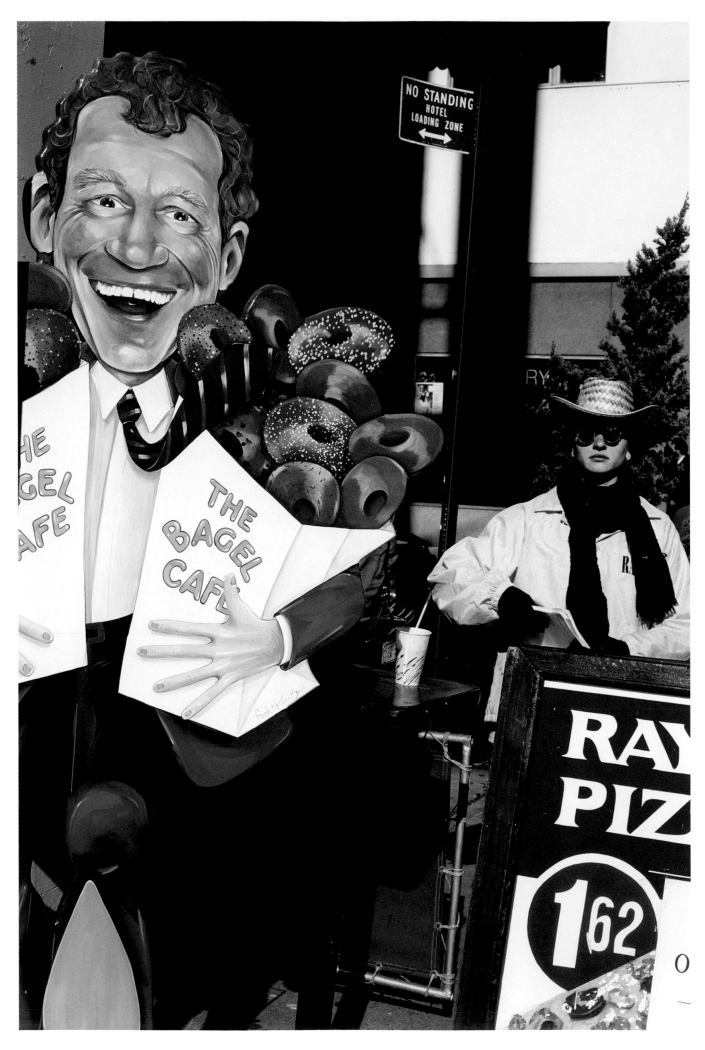

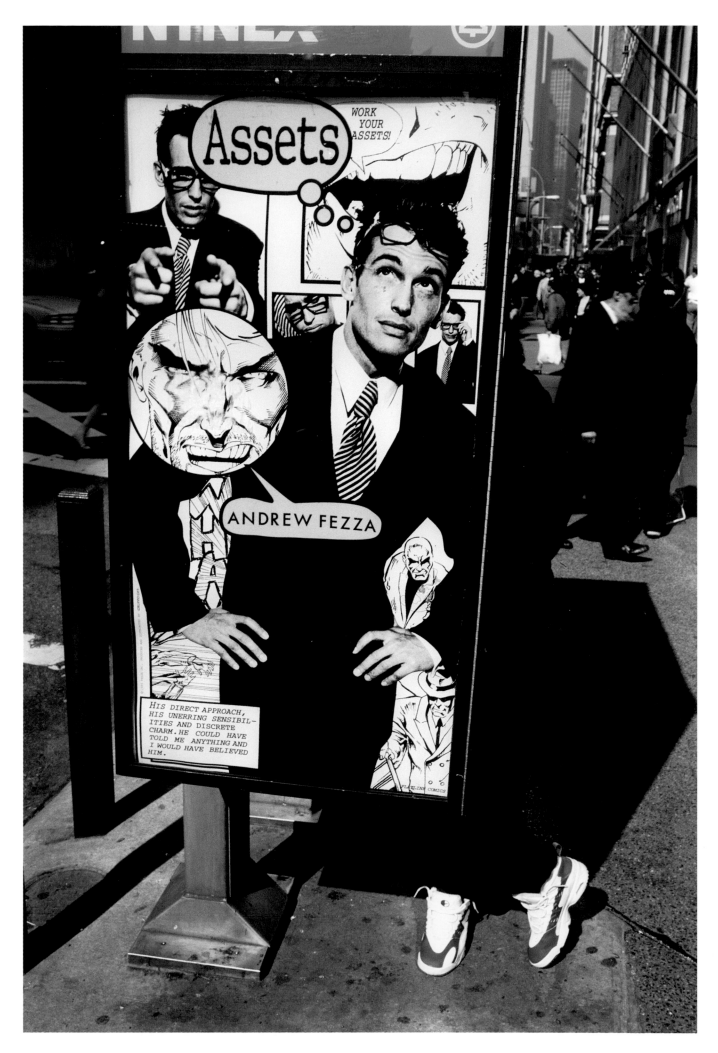

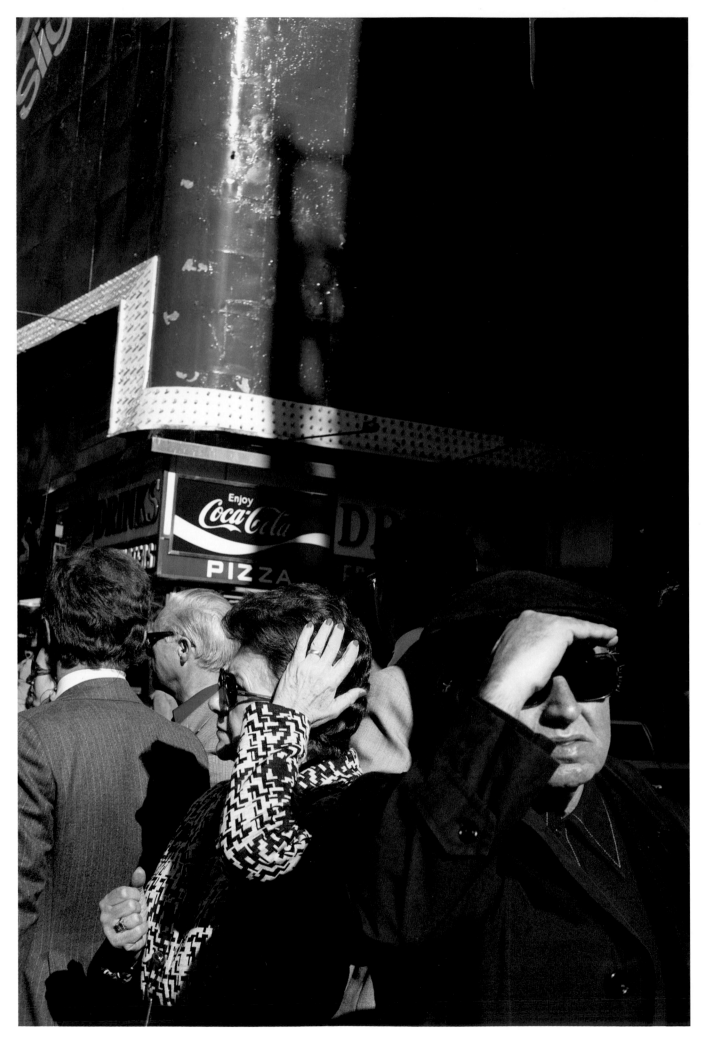

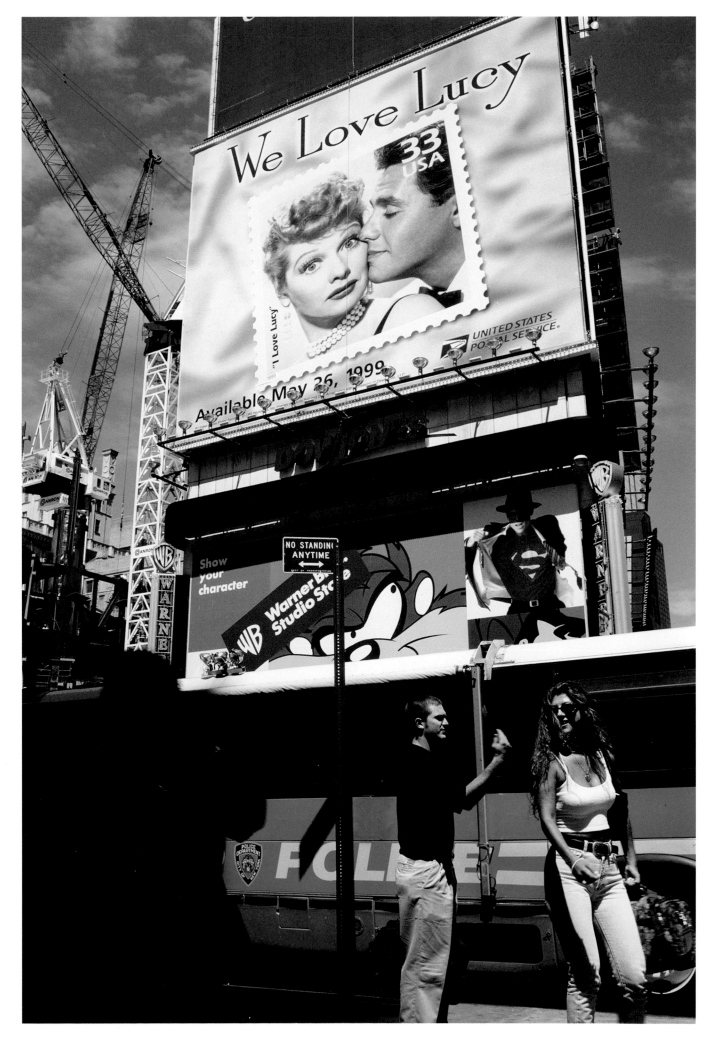

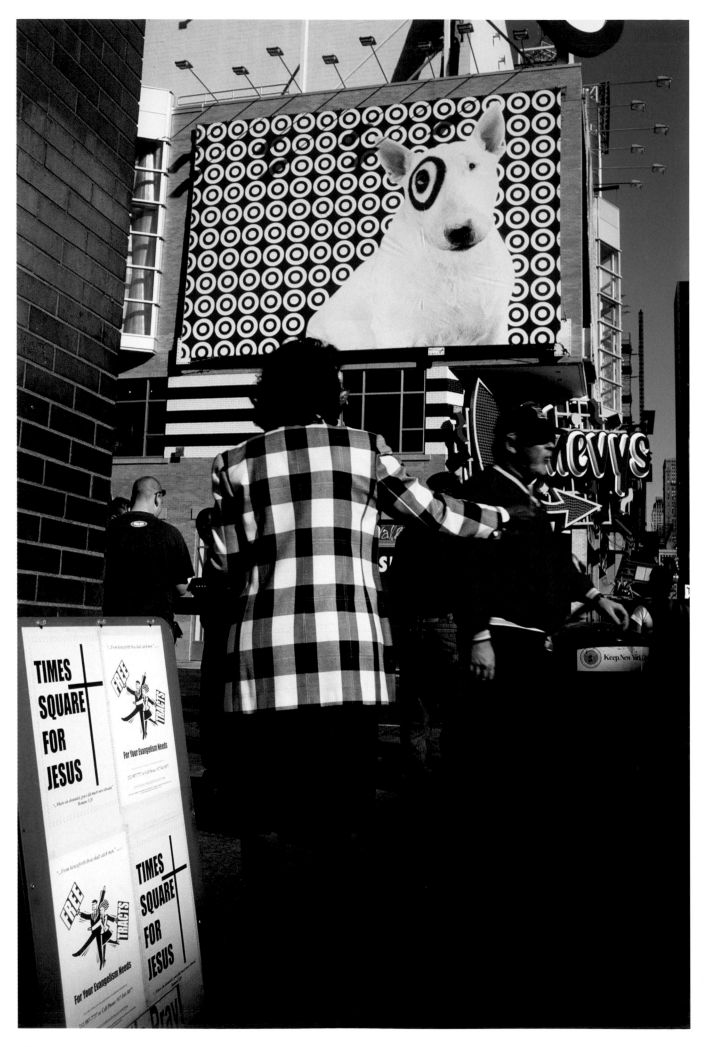

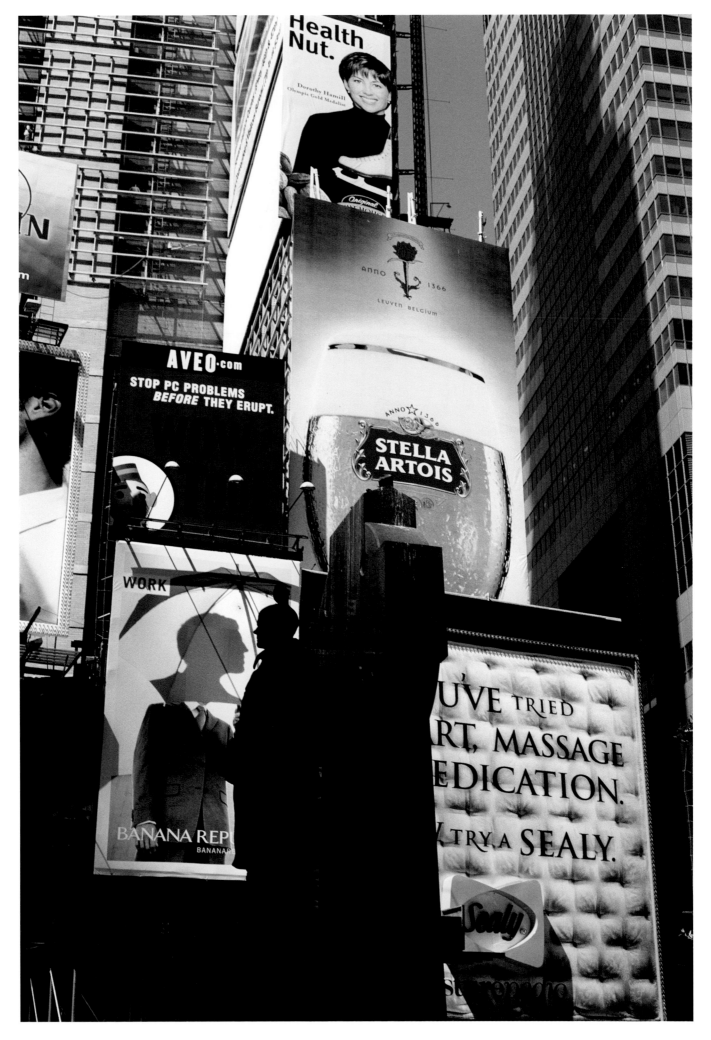

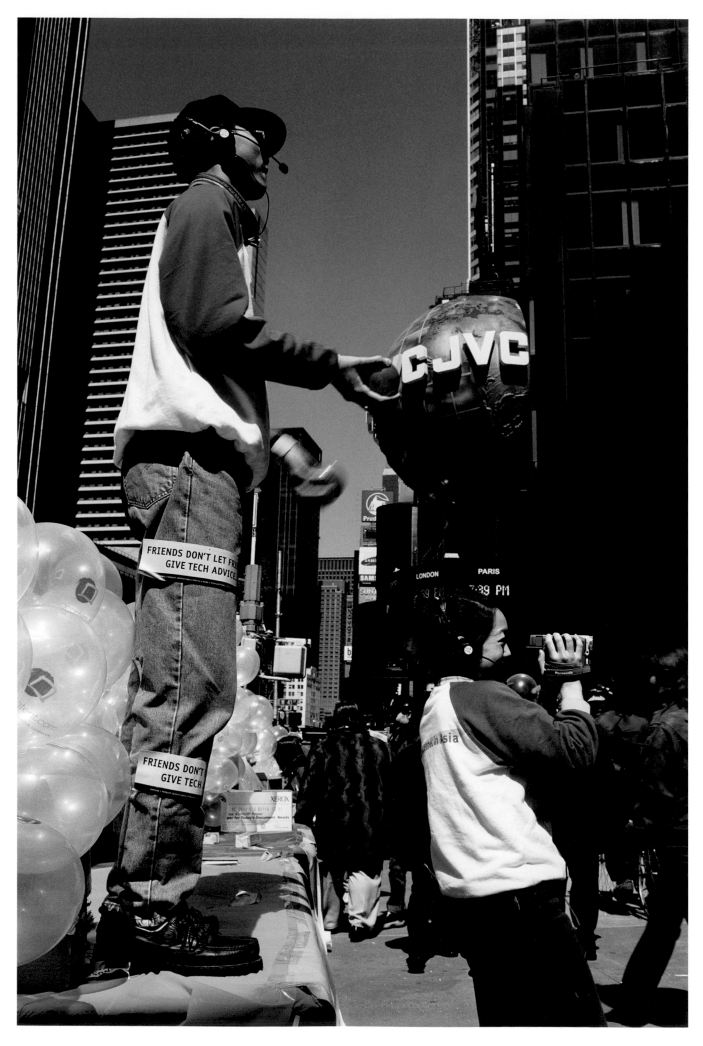

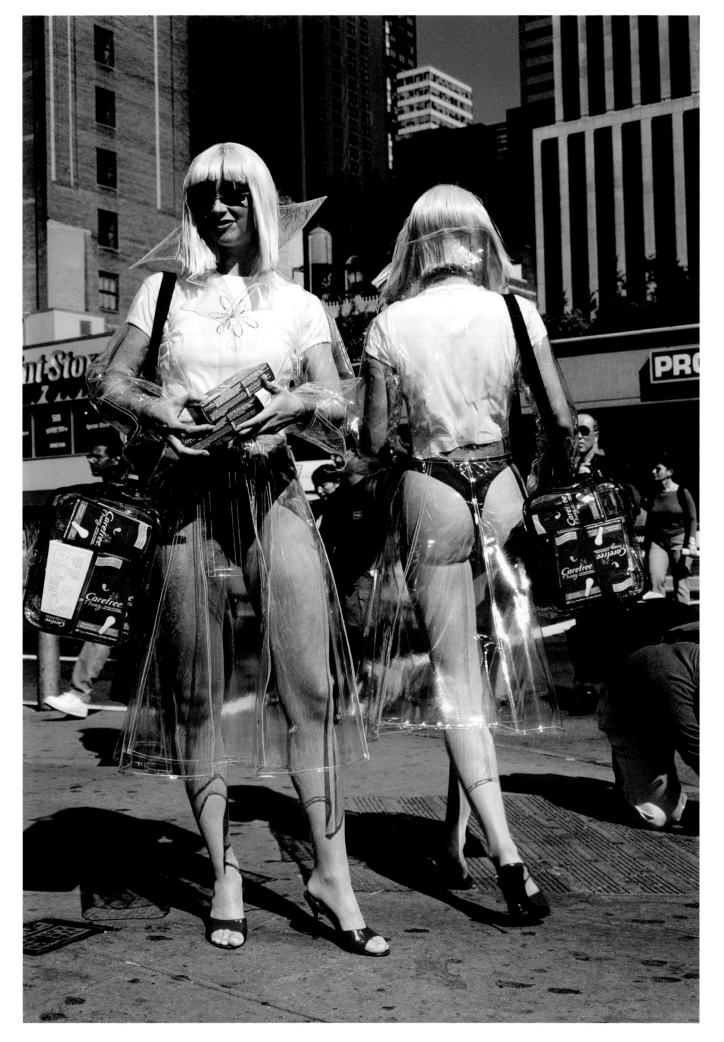

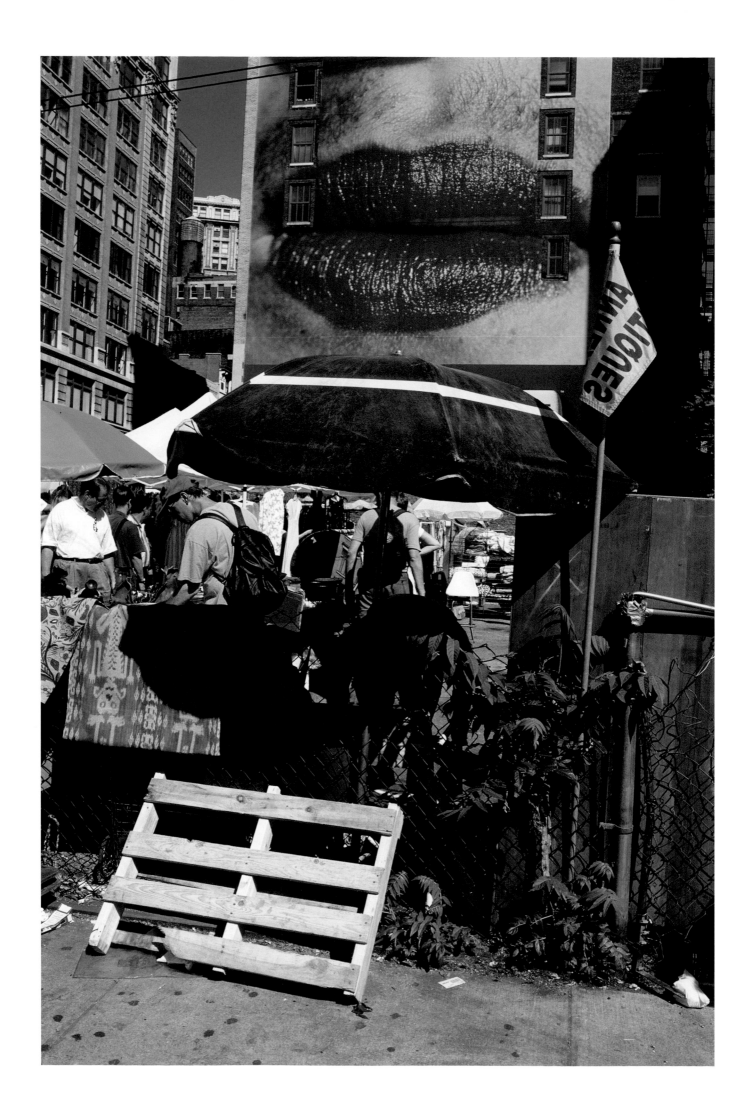

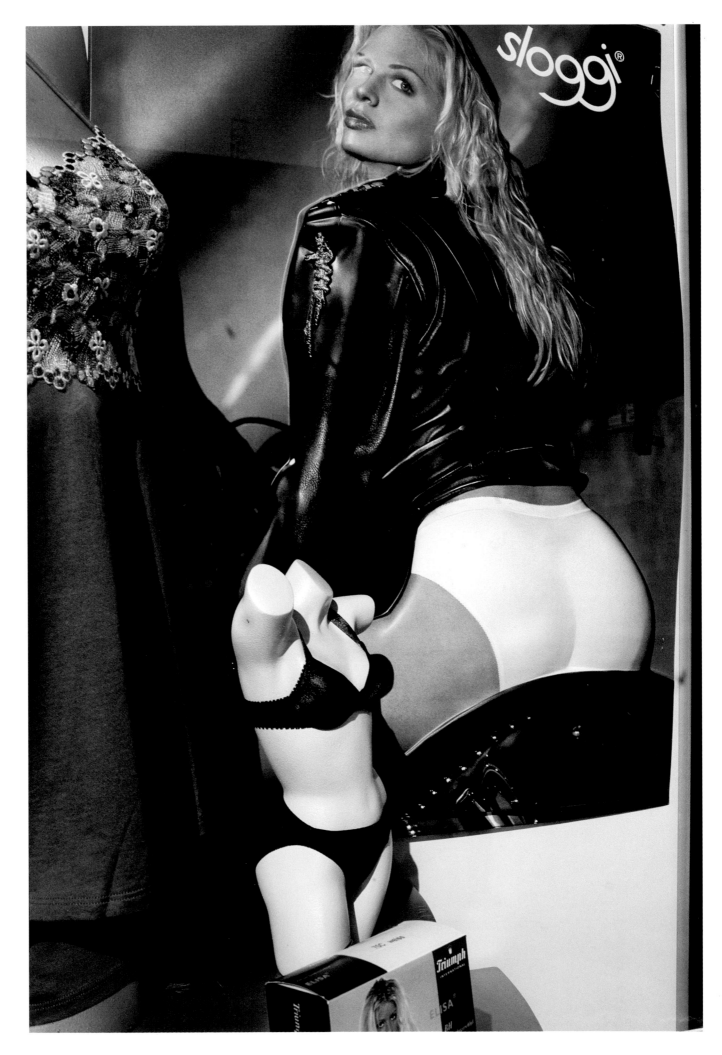

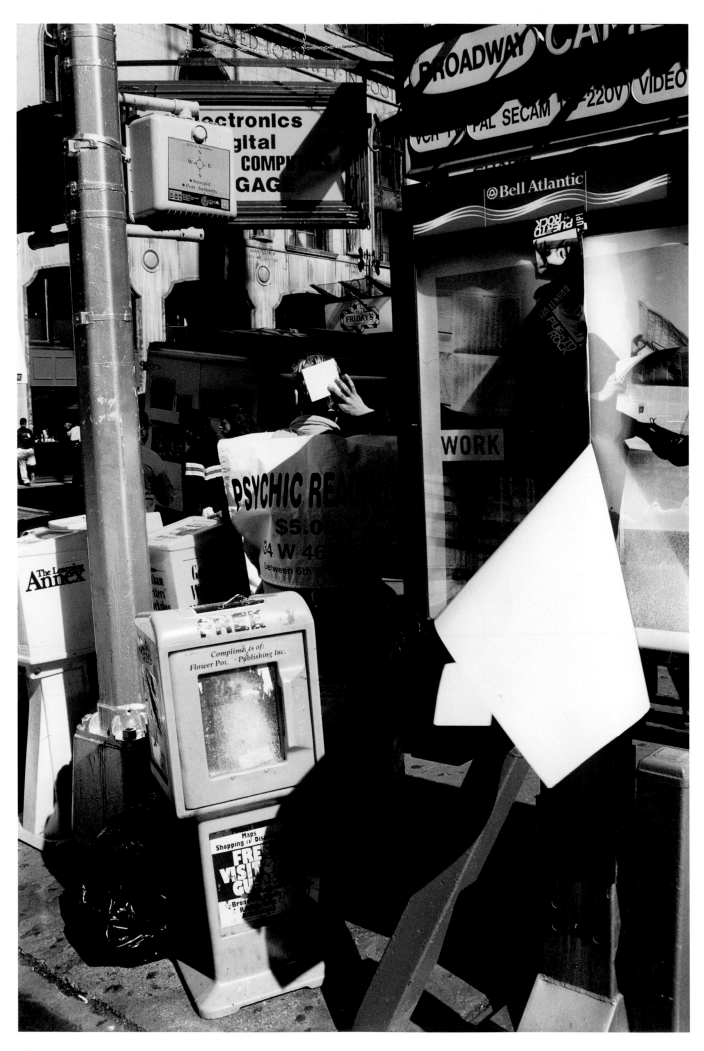

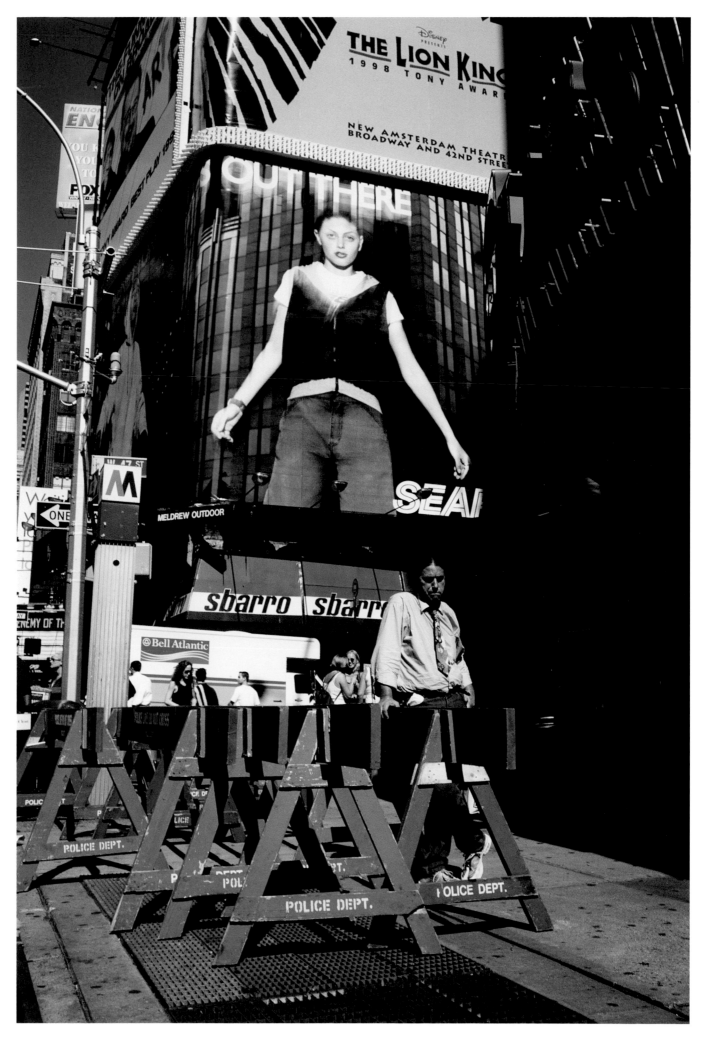

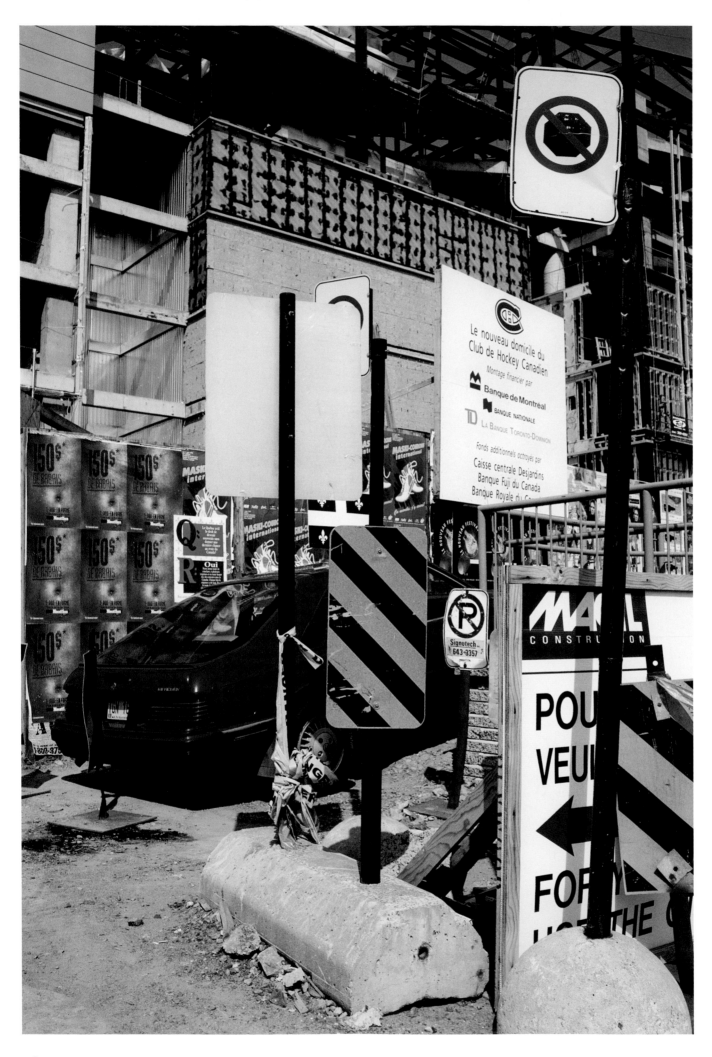

128

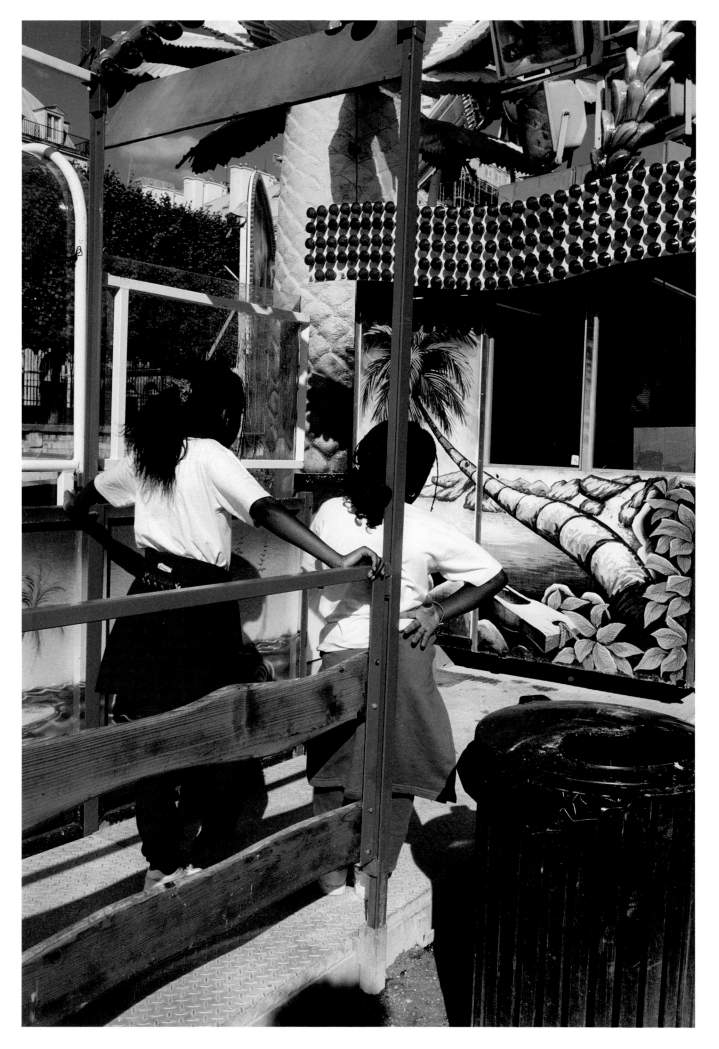

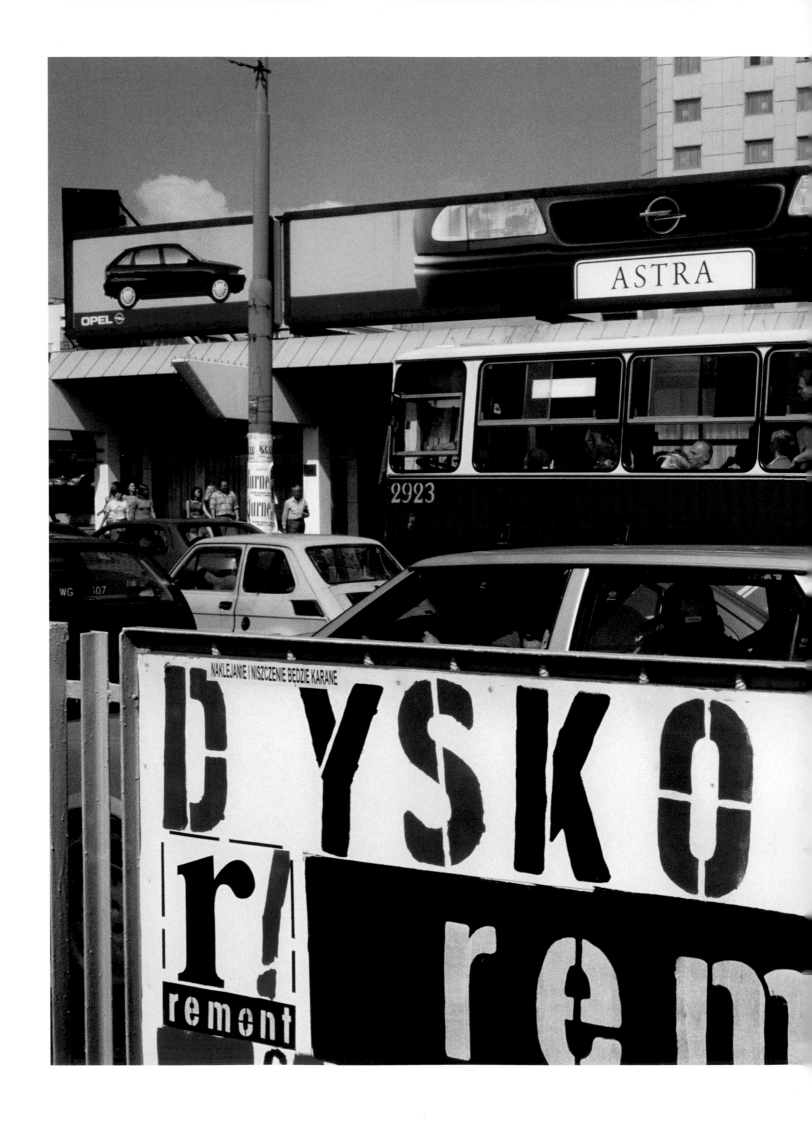

130

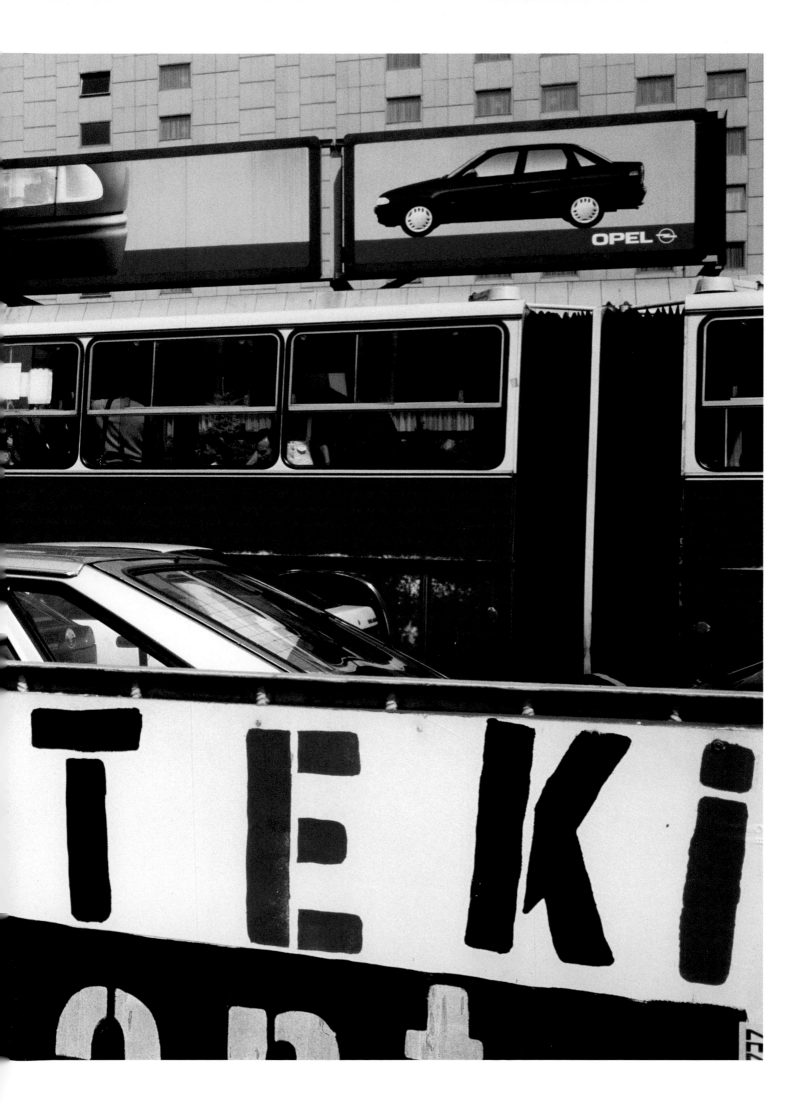

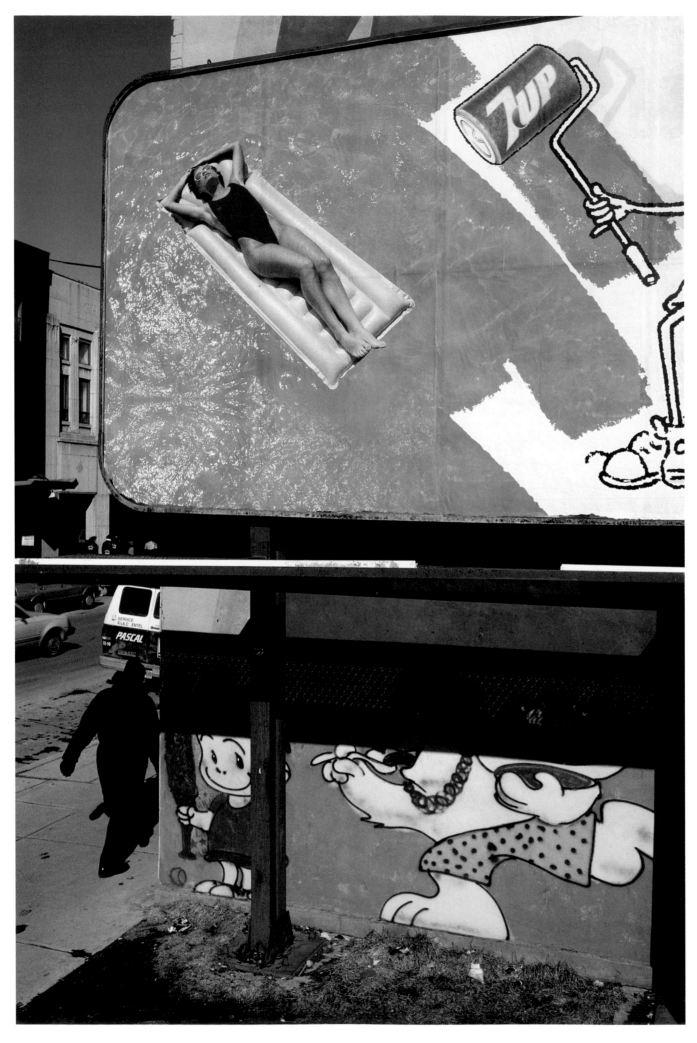

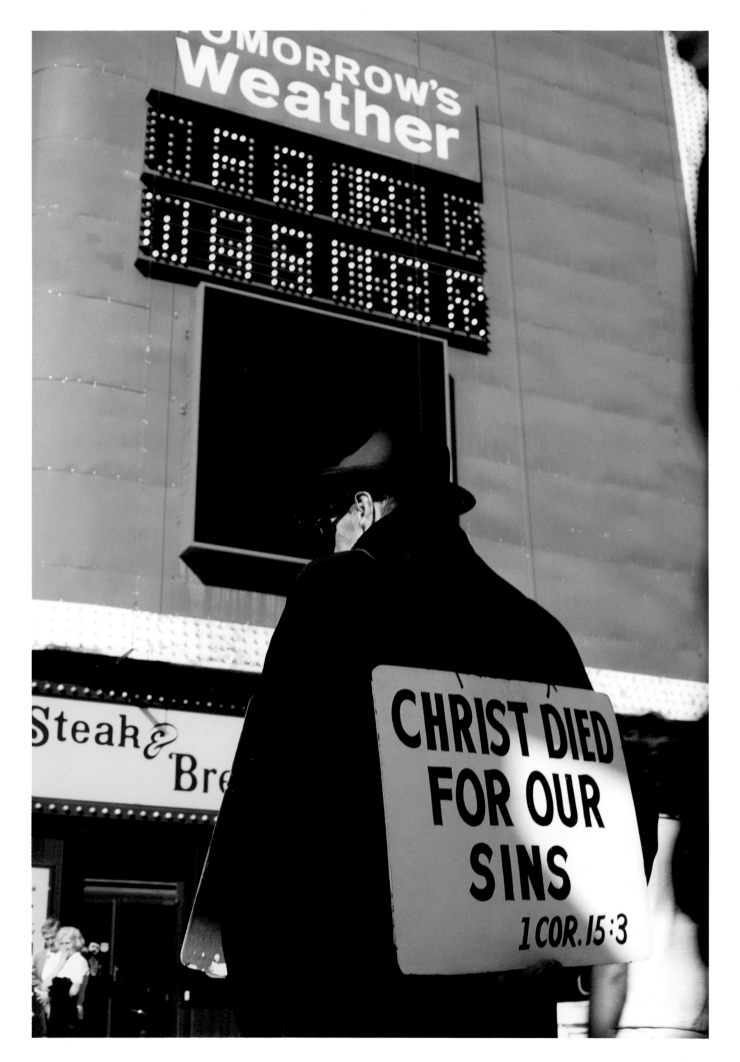

The photographs in this book were taken in the following cities: **New York:** Page 4, 6, 11, 12, 15, 17, 18, 19, 22, 24, 29, 33, 35, 40, 42, 43, 44, 45, 48, 49, 51, 53, 55, 60, 61, 62, 66, 68, 69, 71, 78, 79, 81, 82, 83, 84, 85, 86, 87, 89, 90, 91, 94, 99, 100, 104, 105, 108, 109, 112, 114, 115, 116, 117, 118, 119, 120, 121, 122, 123, 126, 127, 133, **Warsaw:** 14, 25, 26, 32, 37, 50, 54, 102, 125, 130, **Montreal:** 31, 36, 46, 47, 63, 64, 67, 72, 76, 80, 96, 97, 103, 107, 128, 132, **Paris:** Page 27, 73, 129 **Rome:** 28, 30, 65 **Toronto:** 58, 98 **Provincetown:** 101, 103